T0286915

ABERYSTWYTH REFLECTIONS

William Troughton

AMBERLEY

In memory of Robert Jenner (1949–2021), who so enjoyed his visits to Aberystwyth.

First published 2023

Amberley Publishing
The Hill, Stroud, Gloucestershire, GL5 4EP
www.amberley-books.com

Copyright © William Troughton, 2023

The right of William Troughton to be identified as the
Author of this work has been asserted in accordance
with the Copyrights, Designs and Patents Act 1988.

ISBN 978 1 3981 0636 9 (print)
ISBN 978 1 3981 0637 6 (ebook)

All rights reserved. No part of this book may be reprinted
or reproduced or utilised in any form or by any electronic,
mechanical or other means, now known or hereafter
invented, including photocopying and recording, or in
any information storage or retrieval system, without the
permission in writing from the Publishers.

British Library Cataloguing in Publication Data.
A catalogue record for this book is available from the
British Library.

Typesetting by SJmagic DESIGN SERVICES, India.
Printed in Great Britain.

Introduction

To the casual observer Aberystwyth may seem similar to others in the chain of seaside resorts along the west coast of Wales, fitting snugly between Cardigan Bay and the Cambrian Mountains. Aberystwyth though is a multi-faceted town with more to offer than most seaside resorts the world over.

To some it is a seat of learning, deserving of the sobriquet 'The Cultural Capital of Wales'. Aberystwyth University was founded and paid for by the people of Wales, miners and quarrymen contributing their pennies and sixpences urged on by their nonconformist chapels, of which Aberystwyth also boasts a fair share. Today the university has over 8,000 students studying across three academic faculties and seventeen departments. The town is also home to the National Library of Wales, one of only six copyright libraries in the British Isles. It now houses over 6 million books and numerous other treasures. As a result the town can boast more books per head of population than anywhere else in the United Kingdom. Sitting on Penglais Hill above the Library and surrounded by the architecture of academia is the largest arts centre in Wales, featuring a concert hall, theatre, cinema, dance studios, café and bar.

To others it is a holiday resort, 'The Brighton of Wales' as Henry Wigstead (magistrate, publisher, amateur painter and caricaturist) called it in his 1797 guidebook to Wales. Others have called it 'The Biarritz of Wales'. T. O. Morgan, writing in 1848 on the approach from Penglais Hill, likened the town to Venice, 'rising proudly out of the sea'. Comparisons can only go so far; the town is unique and no accolade can fully do it justice.

To those sensible enough to live here it is a home surrounded by natural splendour, full of innate character, multi-cultural and with a friendly face on every corner. Banners of diversity in the form of flags of small nations flap in the breeze on the promenade, while the sense of community that started with Neolithic settlers 6,000 years ago is as strong as ever.

The aim of this book is to show how the town has developed through the blending of old and new images. Many of the older photographs date from the early twentieth century when Aberystwyth as a resort was in its heyday. There are also views of the town from most subsequent decades. Enjoyment of *Aberystwyth Reflections* will be heightened by reference to its sister publication, *Aberystwyth Through Time* (2010).

Much of the book is designed as a tour around the town and district. Page 79 onwards is devoted to notable events, many a result of freak weather conditions. The tour starts with a view by Victorian photographer Francis Bedford, or more likely his son William, who visited the town in 1867 for the purpose of taking 'views of the more charming bits of scenery'. At the time building on the promenade extended only as far as the Queens Hotel. The promenade itself has been constructed and deviates outwards from the cliff line behind. It is perhaps this encroachment on Neptune's realm that contributed to the events of January 1938, detailed on page 81. On Victoria Terrace we pass the first hostel in Britain built for female students, Wales' tallest timber-framed building and a house once occupied by Sir John Williams, the Royal Physician. Call in for a drink if you like as it's now part of the Glengower Hotel (CAMRA Best Pub in Wales 2016). At the end of Victoria Terrace is Victoria House. A plaque identifies it as the residence of another Aberystwyth worthy,

3

T. F. Roberts, Principal of the University from 1891 to 1919. Passing the Hotel de Ville-style Queens Hotel we come to the hub of the promenade where we find the bandstand and site of the undeservedly maligned Kings Hall. This area once bustled with activity as boatmen touted for custom and donkeys waited patiently for riders whilst families enjoyed the beach. Further along we come to the Pier, castle and Old College. The latter is undergoing extensive refurbishment in a £27 million project. Rounding Castle Point we come to the harbour, for centuries the town's gateway to the outside world. This is no longer so but the moderate activity, colour and serenity, especially when bathed in evening sunshine, provide a sense of calm and tranquillity, if a little pungent on a hot summer's day.

A gentle walk takes us through Penparcau and Llanbadarn, once villages distinct from the town but now part of the Aberystwyth conurbation, as is the Parc Y Llyn development that lies in the flood plain of the River Rheidol between the two. From here it is a short walk back into the town to walk the streets and see the changes to a number of local business premises, reminisce about the restaurants inhabited in our younger years before making for the Arts Centre on Penglais Hill.

Change is constant and insidious. Only by looking back do we really notice how much the town has changed and appreciate what we have. The Celts who fortified Pen Dinas, the monks who settled in Llanbadarn in the tenth century and the Norman conquerors responsible for building our castle have all left their mark. What will we in the twenty-first century leave behind?

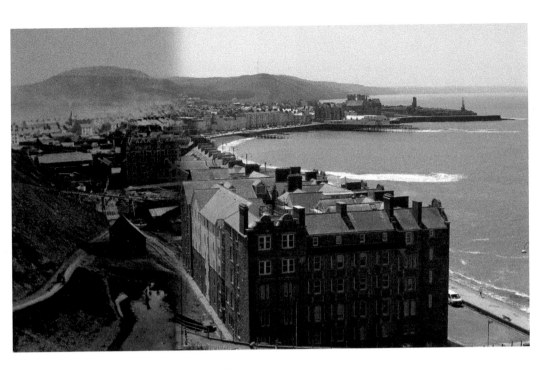

Aberystwyth from Constitution Hill

The roots of Aberystwyth's current prosperity lie with the arrival of the railway. The line from Shrewsbury opened in 1864, that from Carmarthen three years later. The influx of visitors from the Midlands sparked a building boom, especially at the north end of the promenade, photographed here by pioneering photographer Francis Bedford, or more likely his son William, in April 1867.

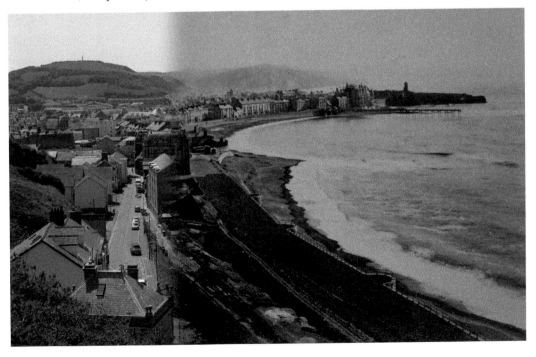

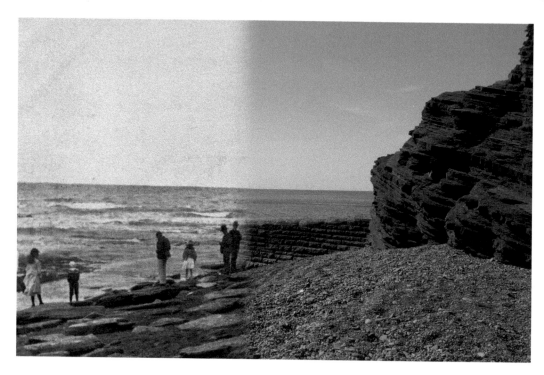

Breakwater at Craiglais

Concern had been expressed over many years about the action of the sea in gradually moving pebbles to the north through longshore drift. This became an even greater concern after the construction of the promenade north of the Queens Hotel. Consequently in 1906 the stone breakwater, now in urgent need of repair, was built along with its twin on Castle Point. The contrasting level of the shingle on the next page shows its effectiveness.

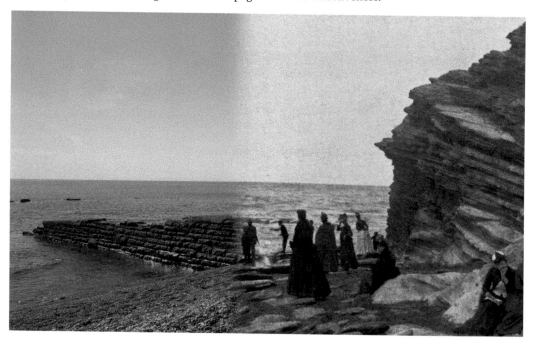

Cliffs at Craiglais

For the Victorian visitor it was the appeal of the area's natural splendour that attracted them, in particular the sea. A stroll along the shingle beach to Craiglais became a popular walk, at least when the tide was out. The more adventurous took time to admire the rocky coastline and towering cliffs, explore St Matthew's Cave, perhaps even venturing as far as Cormorants Rock. At one time this promontory was referred to as Target Point as it was here the local militia had their rifle practice.

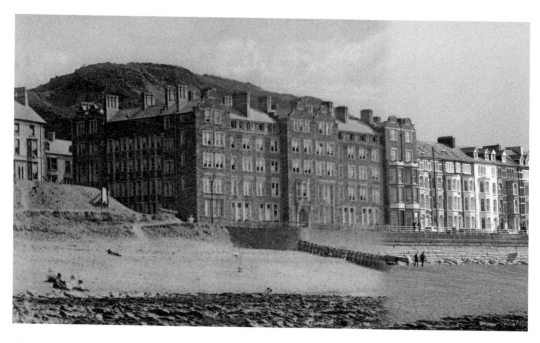

Alexandra Hall

Named after and opened by Princess Alexandra, this was the first student hostel in Britain built exclusively for women students. Built of local stone and buff sandstone from Grinshill Quarry in Shropshire and having a frontage of 118 feet and accommodation for 200 students, the hall was opened on 26 June 1896. On the same day Princess Alexandra opened the Cliff Railway and the Pier Pavilion. Meanwhile her husband, the future Edward VII, was installed as the Chancellor of the University of Wales.

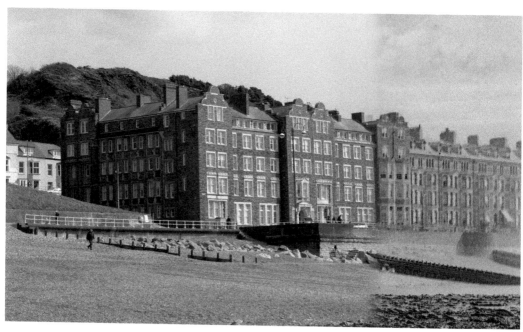

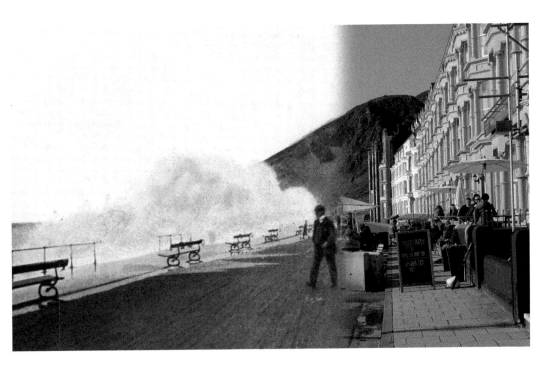

Victoria Terrace

Named in honour of Queen Victoria and built piecemeal in the later decades of the nineteenth century, the fine houses in Victoria Terrace were at the time of the earlier view nearly all guest houses. A famous resident was Sir John Williams (1840–1926), royal physician and generous benefactor to the National Library of Wales. His house is now incorporated into the Glengower Hotel, whose socially distanced customers can be seen enjoying an alfresco drink.

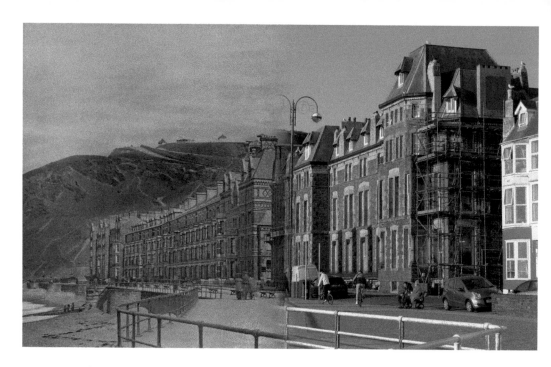

Queens Hotel

Built in anticipation of a tourist boom following the arrival of the railway, the Queens Hotel opened in 1866, being modestly advertised as 'one of the most noble and convenient structures in the kingdom [being] entirely protected from the north and east winds by the Craiglais mountain range; and for the convenience of invalids, to whom the climate is especially desirable, a range of rooms has been provided on the ground floor'. The hotel closed in 1951 to become council offices and briefly the police station for the television detective series *Hinterland*. Its future remains uncertain.

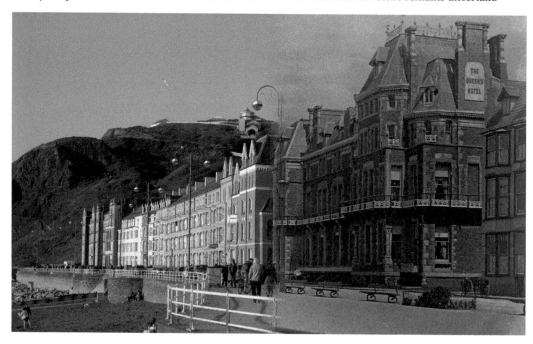

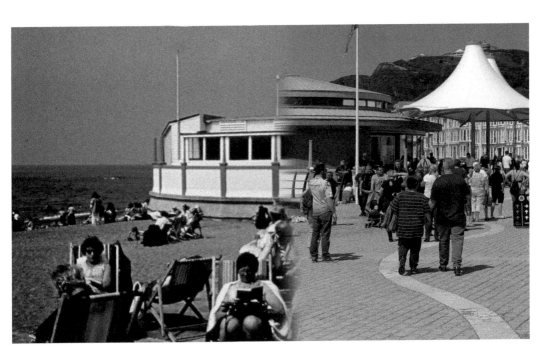

Bandstand

The origins of the present bandstand lie in the sturdy construction of Aberystwyth's Jubilee Bandstand, built to celebrate the silver jubilee of King George V in 1935. Over the years it has been much modified, most recently a major refurbishment and modernisation in 2016 following storm damage two years earlier. Up until the late 1970s deck chairs were provided (for a small fee) on the promenade for those enjoying the entertainment or merely to take in the sun.

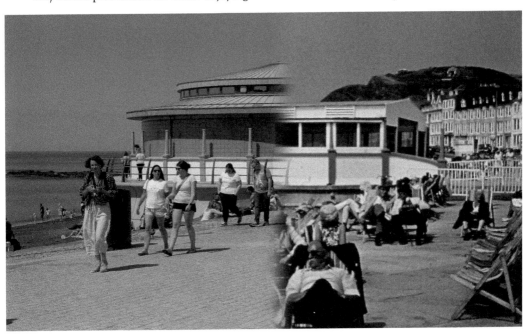

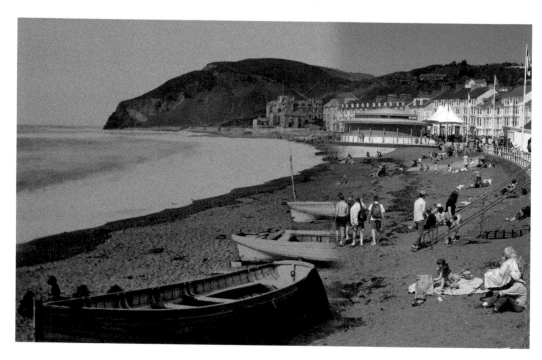

The Beach I

When Francis Bedford sent his son William to photograph Aberystwyth in April 1867 the beach boasted a number of smartly painted rowing boats ready to take visitors for a row around the bay. There were often complaints about overloading and the boatmen canvassing for custom. In 1873 the boatmen complained that concerts by Mr Crawshay's band on the pier were proving so popular that they were being kept idle.

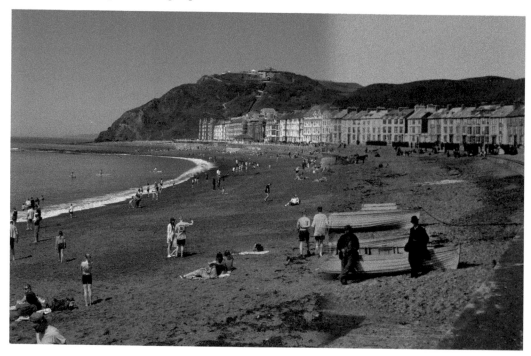

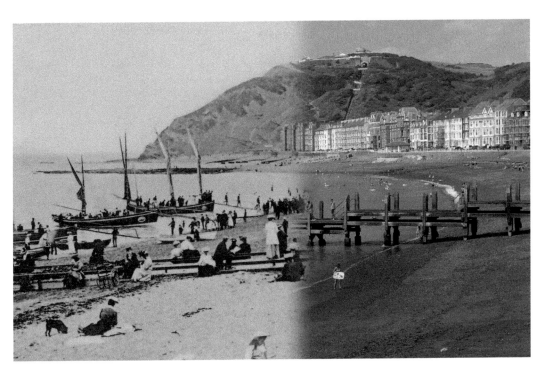

The Beach II

By the early 1900s trips in the bay were big business with a variety of craft plying for trade. These included small steamers such as *Lizzie* and *May* and larger Aberystwyth beach boats, a type of boat almost unique in having a pointed stern (to stop passengers being splashed) thought to have originated in nearby Borth a few decades earlier. Allegations of overloading and enthusiastic touting for custom continued to be frequent accusations in the local newspapers.

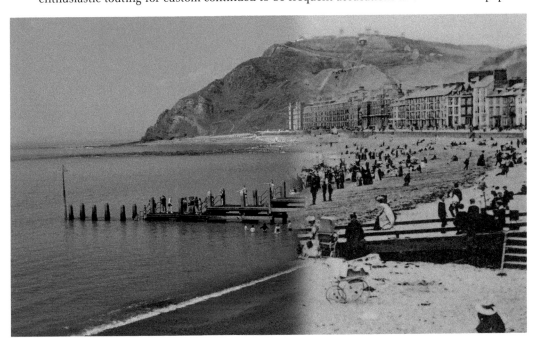

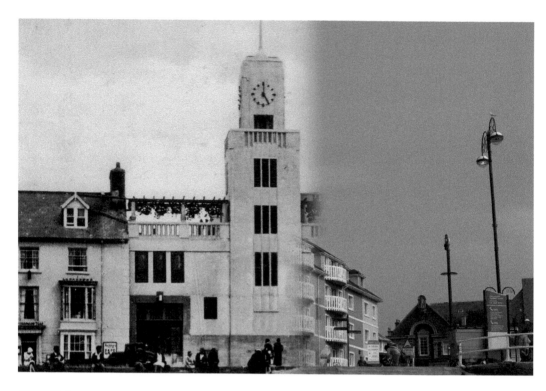

Kings Hall

The Kings Hall originally opened with the banal name 'Municipal Hall.' It was a popular dance hall, concert venue, theatre and exam hall until the 1970s. Once the Arts Centre on Penglais opened it lost many of these functions. Concerts were still held there – Marillion and China Crisis both played there in the early 1980s – but a lack of municipal imagination led to it being declared 'unsafe'. The myth of this declaration hit home as the wrecking ball tried time after time after time to demolish a very soundly built structure. It was replaced with Aberystwyth's answer to everything – flats.

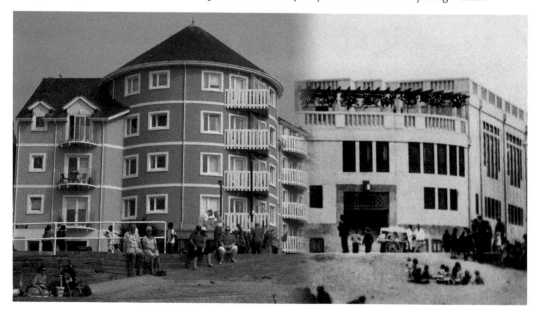

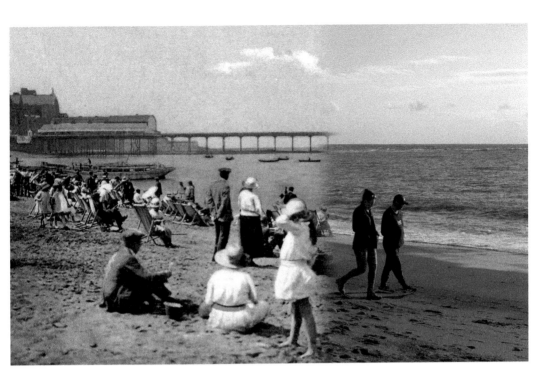

The Beach and Pier

When first opened in 1865 the Pier was 242 metres long. The storm of 1938 was responsible for truncating the pier to its present length. The pavilion was added in 1896 and opened by Princess Alexandra. Capable of seating 3,000 people, the pavilion was a popular cinema until closed by a fire in 1961. Extensive investment by Don Leisure in 1979 saw the pier rejuvenated. It now includes a snooker club, pub, nightclub and restaurant.

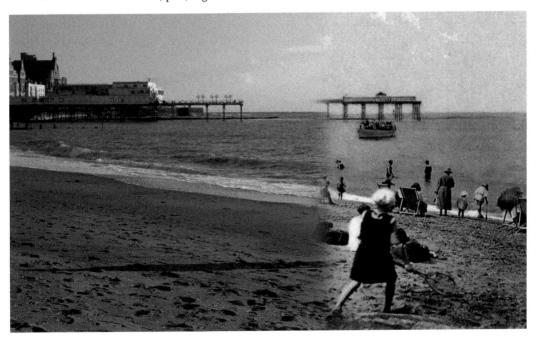

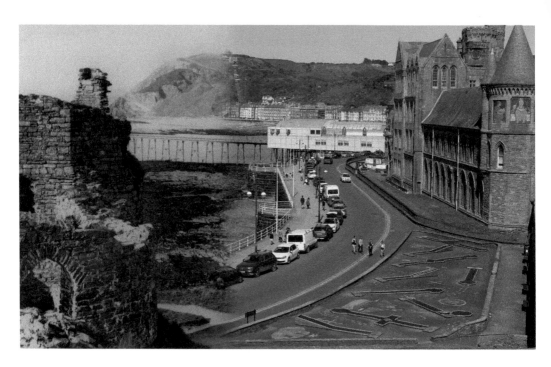

New Terrace, College and Pier

Built for the expected boom in visitors with the arrival of the railway over 150 years ago, the Old College has started to show its age. In 2018 to counter this the university announced a £27 million scheme to revamp the building and provide exhibition galleries, visitor accommodation, a business hub, cinema, virtual reality experiences for public shows, University Museum and a Centre for Advanced Study.

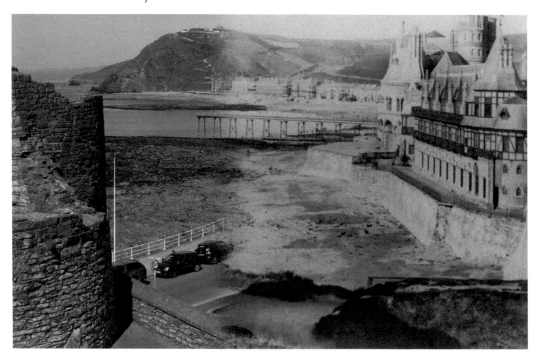

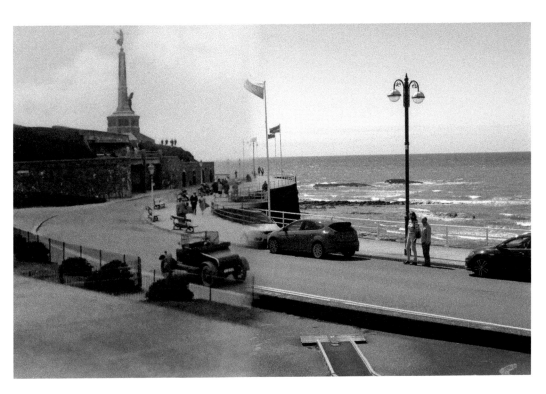

New Promenade and War Memorial, Aberystwyth

This part of the promenade, opened in 1903, was not so new by the time the earlier view, dating from the 1920s, was taken. The war memorial was officially unveiled in 1923. The winged figure on the top represents Victory alighting on the earth with news of victory and peace.

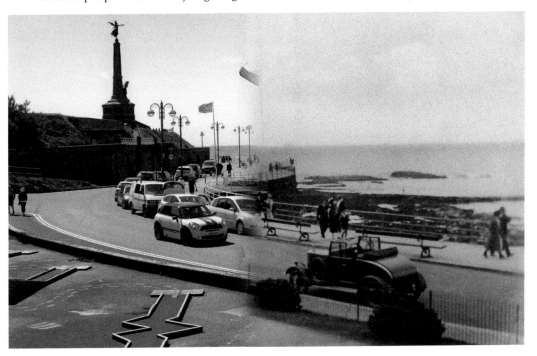

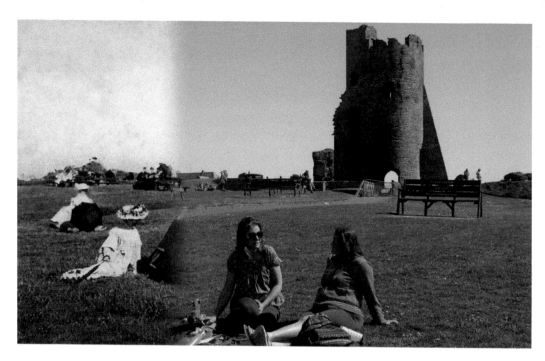

The Castle Grounds

Affording views both up and down the coast the castle grounds have always been popular. In the older view the small meteorological station enclosed by railings can be seen. It was readings from this station that allowed the town to claim record sunshine hours, a slogan that was to be seen on the town's postal cancellation well into the 1960s.

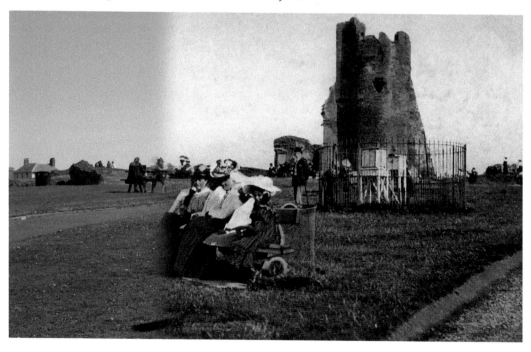

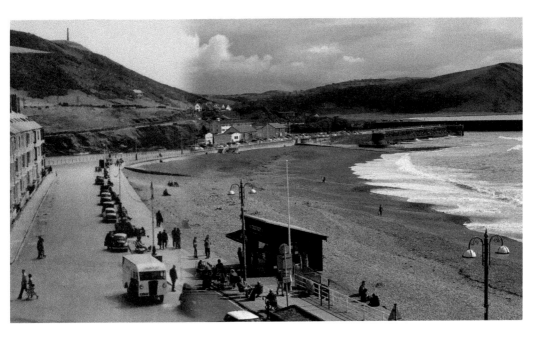

South Marine Terrace I

Originally called South Terrace, the name was changed to South Marine Terrace in 1896. Refreshments have now been available for over sixty years on this part of the prom. The Hut (centre of the photo) is a popular destination for those seeking light refreshment in the sunshine and fresh sea air. On the lower slopes of Pen Dinas is the newly built Maes y Mor extra care scheme for adults with care or support needs.

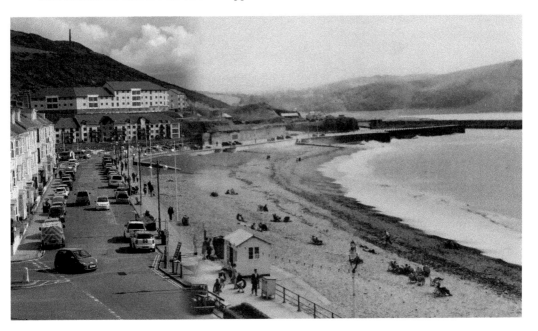

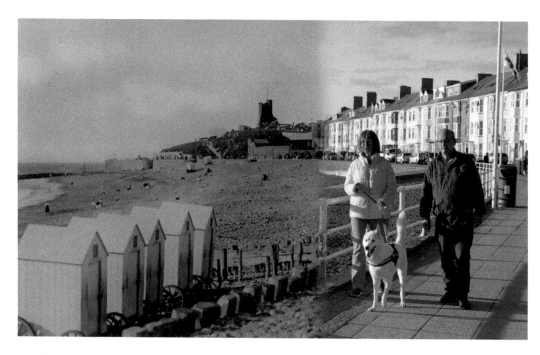

South Marine Terrace II

Lobbying for extending the promenade from South Road to the harbour commenced in 1904 but work did not start until 1929, lasting until 1931. As can be seen prior to this only a thin breastwork protected the roadway from the sea. Bathing machines were available for the more modest bathers until well into the twentieth century.

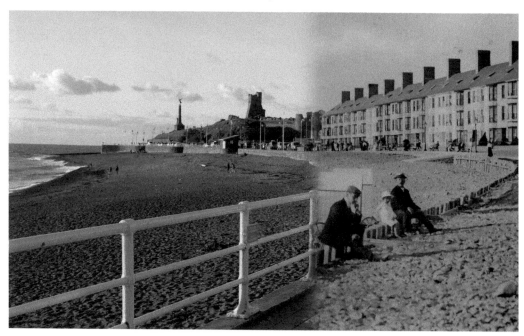

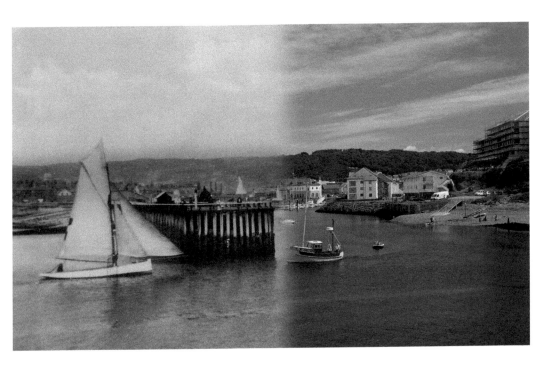

Harbour Entrance

The harbour entrance marks the confluence of the rivers Rheidol and Ystwyth. For sailing ships in particular entering the harbour required local knowledge and considerable skill. Not surprisingly, many vessels have come to grief at this spot including *King Solomon* (1760), *Lusitania* (1833), *Ann* (1857), *Young England* (1862), *Rebecca* (1866), *Selma* (1893) and *Clareen* (1927).

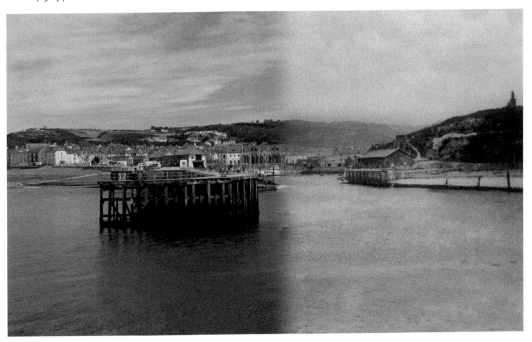

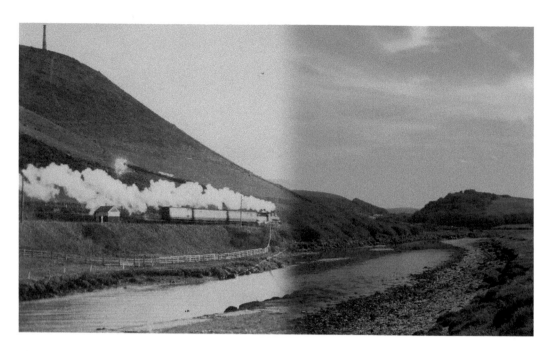

River Ystwyth

The Aberystwyth to Carmarthen railway line was sandwiched between the lower slopes of Pen Dinas and the River Ystwyth. The line opened in 1867 and lasted until 14 December 1964 when flooding washed away a bridge at Llanilar, severing the connection to Aberystwyth and hastening the decision to close the line made in the Beeching Report, published a year earlier. Preliminary investigations are now being made into reopening the line.

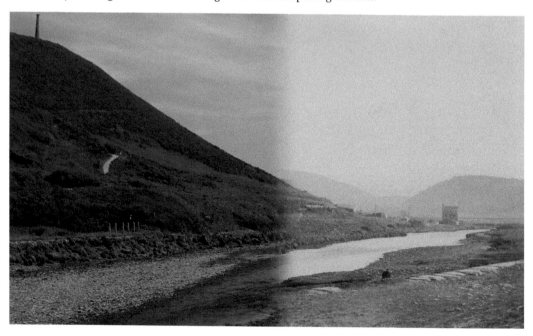

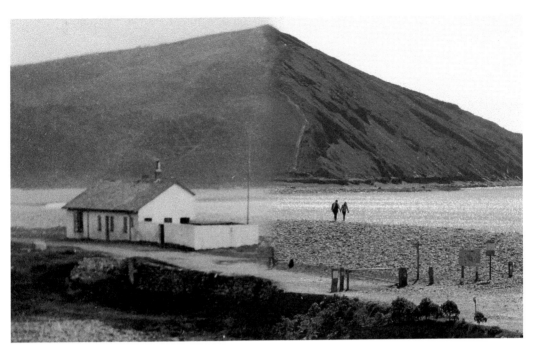

Cottage, Tanybwlch Beach

Despite marvellous views across the bay and of the cliffs at Alltwen, a remote spot on the top of a storm beach does not seem a logical place to build a house. That is until one realises that this was the town's first Infectious Diseases Hospital built to isolate any potential smallpox cases. The folly of building in such a spot was fully revealed in 1938 (see page 82).

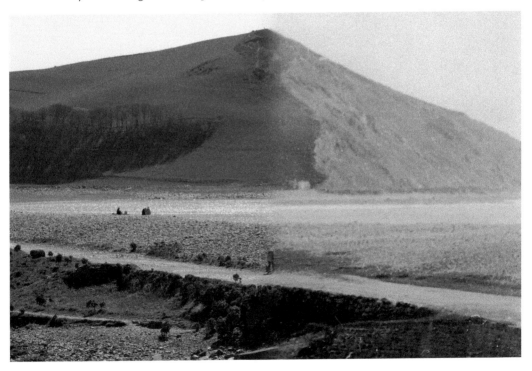

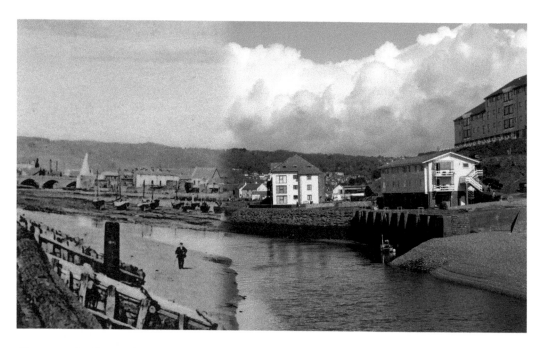

Aberystwyth, The Harbour

On the right-hand side of the older views the steamer *Fram* is unloading a cargo of 319 tons of timber onto St David's Quay in August 1901. At one time this quay was served by a siding of the Aberystwyth to Carmarthen railway line, although it never seems to have been a busy siding. On the hillside above the steamer are the ruins of a warehouse used to store lead ore. It is believed that this was the site of a murder in 1781.

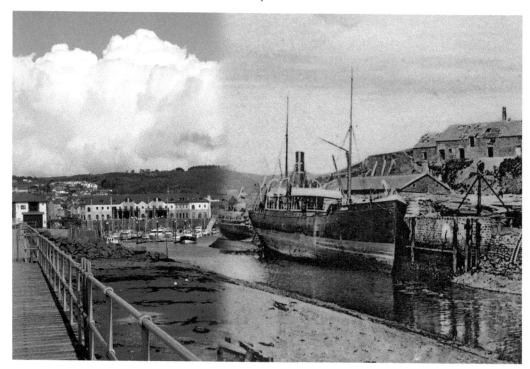

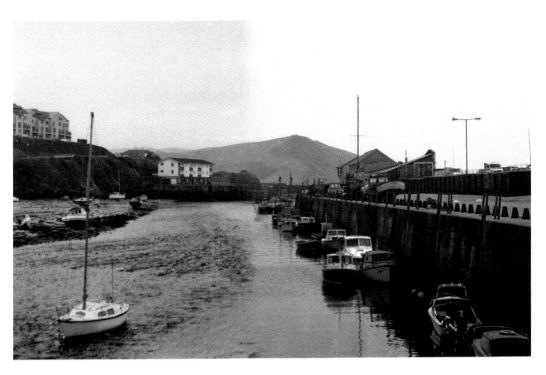

Town Quay

The earlier of these two photos dates from 1982, five years before the Town Quay Improvement Scheme refurbished and strengthened the quayside. The mudflats on the left-hand side were removed to make way for Aberystwyth marina, which opened in 1995.

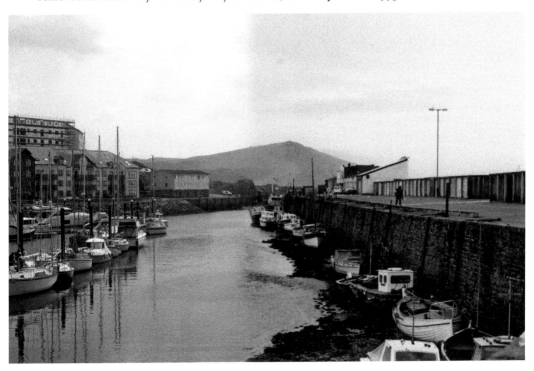

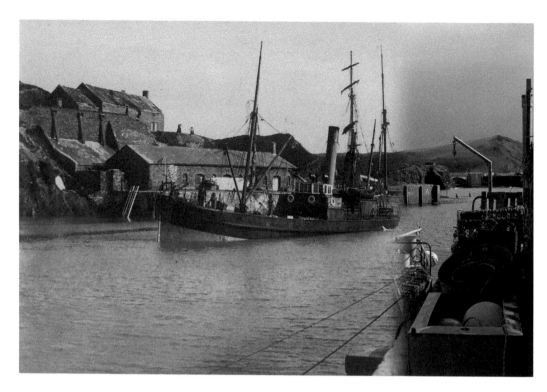

Grosvenor

In the older of the two photos *Grosvenor*, a steamer that ran a regular service between the town and Liverpool, is making its way to the Town Quay. Notice also the lead ore slides on the left-hand side, above St Davids Quay. The modern view is dominated by local fishing boats concerned with fishing for shellfish – predominantly lobsters, prawns and scallops.

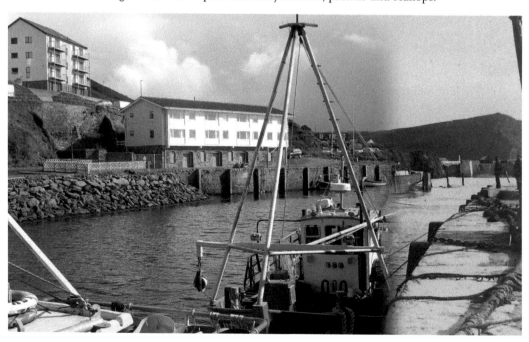

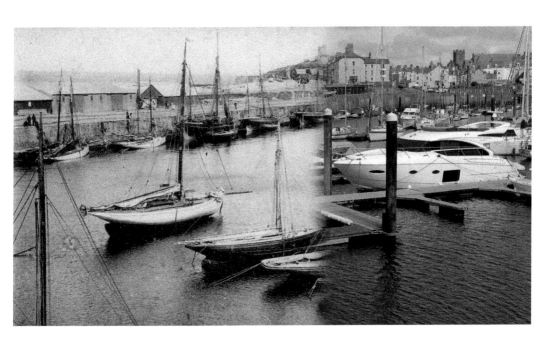

The Harbour, Aberystwyth

The difference between the craft using the harbour over a hundred years ago and today is amply illustrated here, with Morecambe Bay Nobbies dominating the older view. These were wooden boats, originally designed for catching prawns, characterised by a shallow draught, low freeboard and elliptical curving stern. Today sleek yachts and the occasional lavish cabin cruisers have replaced the graceful lines of the wooden 'Nobbies'.

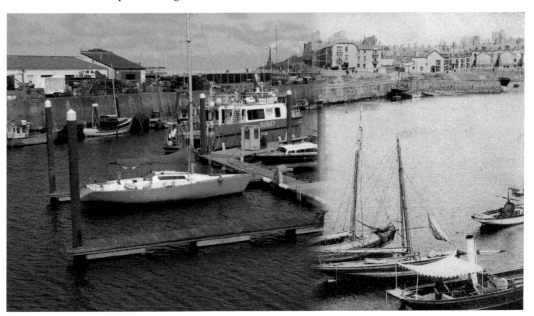

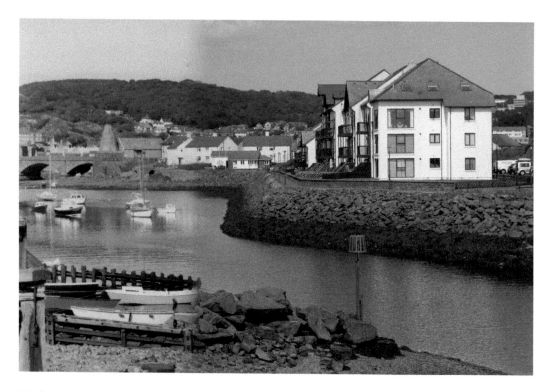

Marina I

The earlier of these two photos dates from *c.* 1985. The extent to which the development of apartments has encroached on the mudflats can be judged from the blending of these photos. The malt-drying kiln built by local brewer David Roberts is now obscured by the Aberystwyth Justice Centre and Marina offices.

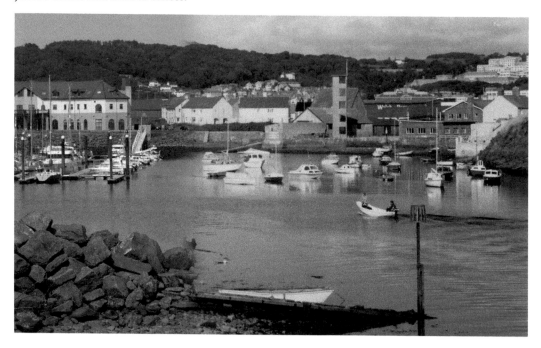

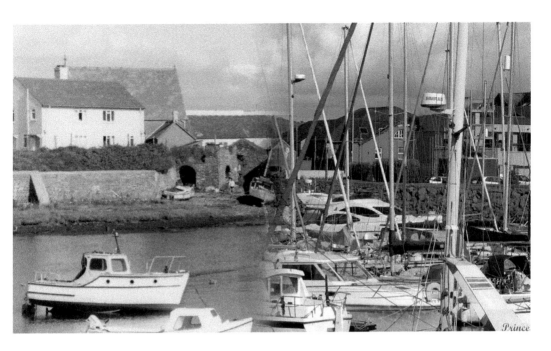

Marina II

Perhaps the transformation in the harbour over the last three decades is no better illustrated than in this image. Gone are the premises of David Williams Boat-builder, Trefechan Sunday School and the fire station practice tower. The mudflats used for mooring all sorts of locally owned small craft have been replaced by a packed marina. Only the rear of Harbour Crescent and the Fountain Inn (painted red in the more recent photo) remain unchanged.

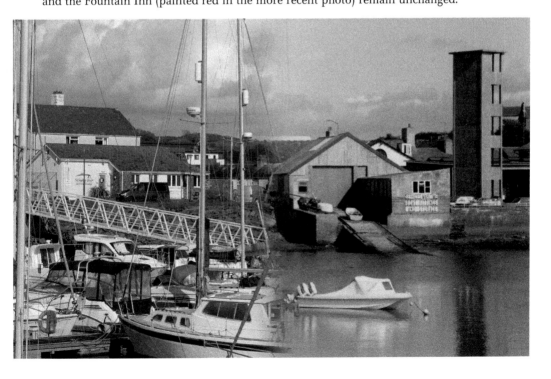

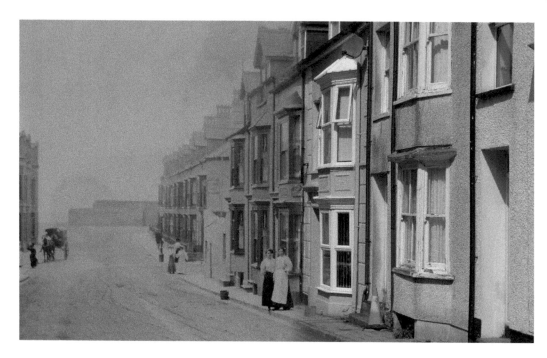

South Road

In an attempt at gentrification the centuries-old and more descriptive Shipwrights Row was changed to South Road in around 1892. South Road now has only one pub – The Castle Hotel. In previous centuries it also boasted a Sailors Arms and a Chain & Anchor and in a nearby street the Shipwrights Arms, all indicative of the importance of the harbour, especially in the nineteenth century.

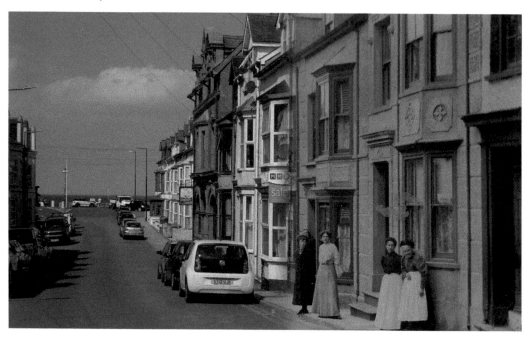

Penparke

Once a village quite separate from the town itself, Penparcau, according to the 2011 census, has a population of 3,122 inhabitants. It still retains its independence as a community with St Anne's Church (built in 1910), a chip shop, Chinese takeaway and a number of small shops. Following the closure of the Tollgate Inn in 2015 Penparcau finds itself without a pub as indeed it was for the first seven decades of the twentieth century.

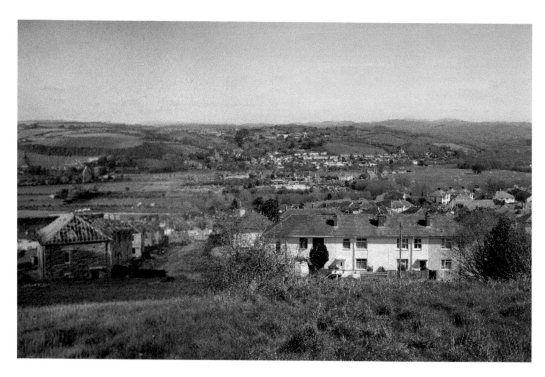

Maesheli, Penparcau

The 1930s are most often associated with the economic depression that afflicted the country. However, it seems that Penparcau underwent a building boom, at least in Maesheli where the bricks, clay drainage pipes, scaffolding and planks testify to the employment created and the improved housing provided at a time when both were needed.

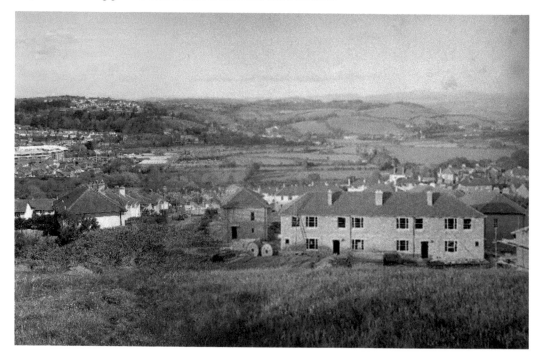

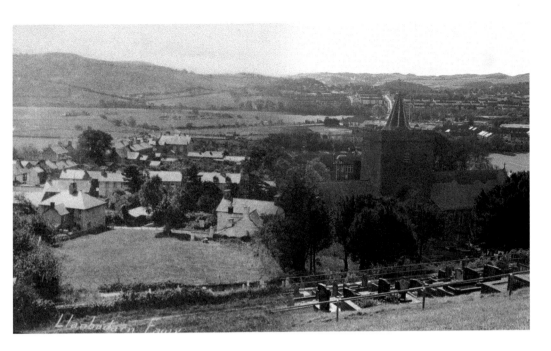

Llanbadarn Fawr

Llanbadarn Fawr faces Penparcau across the River Rheidol and takes its name from St Padarn, a sixth-century sanctified British Christian abbot-bishop who founded a monastery here, hence the impressive church. During the mid-nineteenth century a number of army pensioners, veterans of the Napoleonic wars, lived in the area. It was a condition that to receive their pensions they had to attend Sunday service. They, however, contended that the sermon did not constitute part of the service and popped into the Black Lion next door for the duration of the vicar's oration.

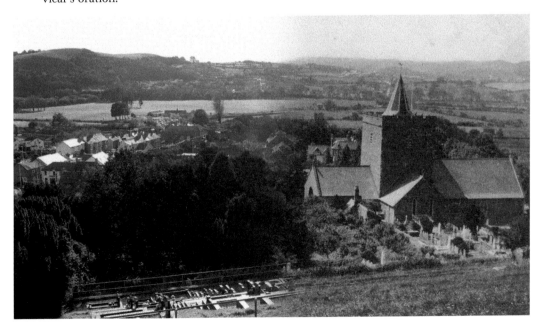

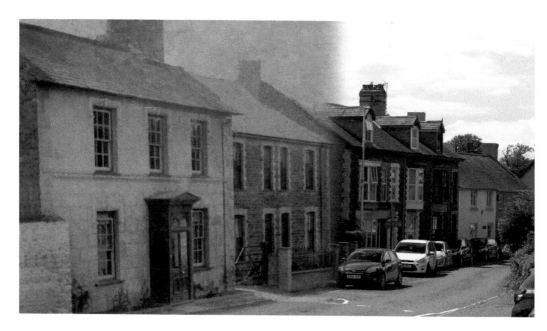

Tanyfynwent

Tanyfynwent translates to 'under the cemetery', a most appropriate name. Up until thirty years ago there were a number of small village shops along this road. Now only the local butcher survives. Until the construction of Ffordd Sulien this narrow road was part of the A44. The road being so narrow accidents were not unusual, such as in November 1906 when Mrs Lewis , hurrying to get out of the way of the Goginan Mail Coach, tripped, hit her head and died shortly afterwards.

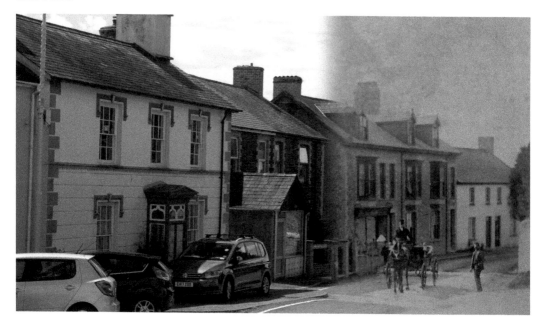

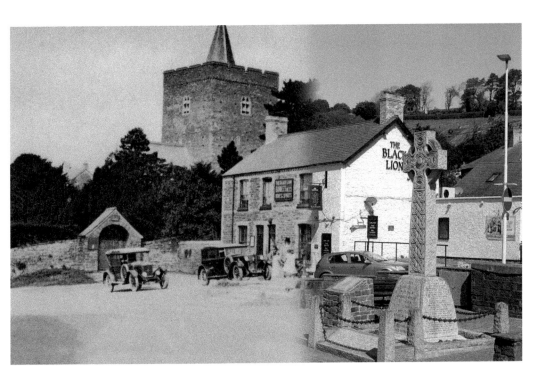

Llanbadarn Fawr Village

The Square in Llanbadarn is dominated by the Black Lion (once a single-storey thatched longhouse), War Memorial and Y Garreg Fawr. The War Memorial includes a tribute to Lewis Pugh Evans, a local soldier awarded the Victoria Cross. Y Garreg Fawr to the right is thought to have been the capstone of a cromlech and later served as an impromptu market stall where local produce was bought and sold. Between Y Garreg Fawr and the lych gate once stood the stocks and whipping post. The church is now almost entirely obscured by trees from this angle.

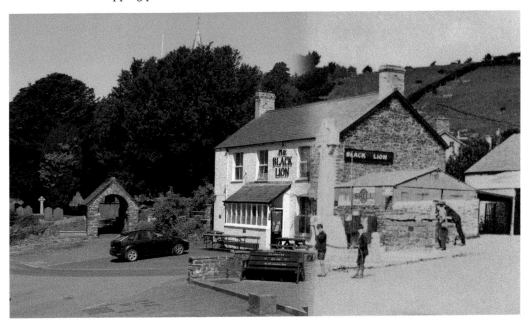

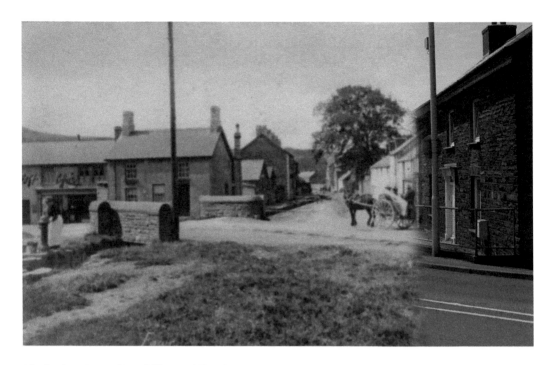

Llanbadarn Fawr, Post Office and Brook Terrace
Two views of Llanbadarn, a century and worlds apart. The large building centre left was demolished many years ago to facilitate traffic improvements, the traffic very obvious now in contrast to the solitary horse and cart in the earlier view. The now-demolished building was at one time a pub, the Talbot. Next to it was the post office, the building is still there but it stopped being a post office twenty or so years ago. Gone also is the village pump, on the extreme left of the older view.

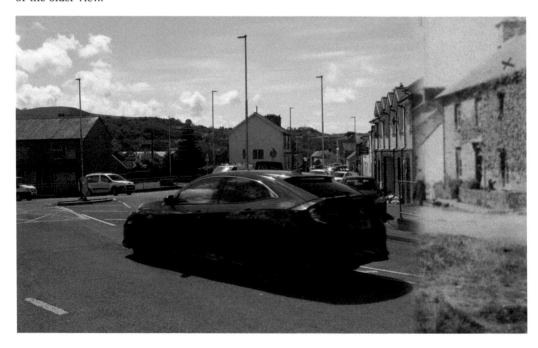

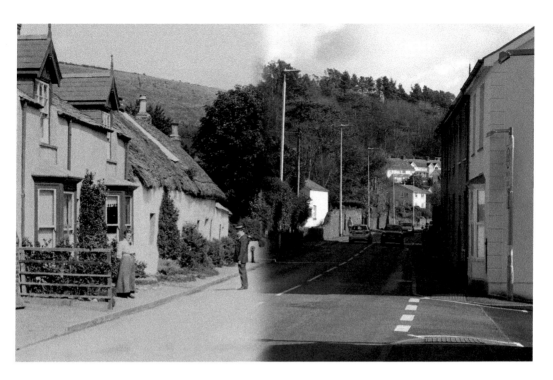

Llain-y-gawsai

Llain-y-gawsai was once a cluster of cottages between Aberystwyth and Llanbadarn Fawr, the name translating as the lane on the causeway, the causeway being the path that led from town to the church at Llanbadarn Fawr. For much of the last century the building on the extreme right was a sub post office.

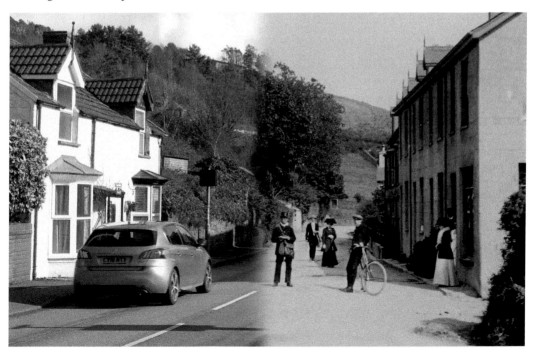

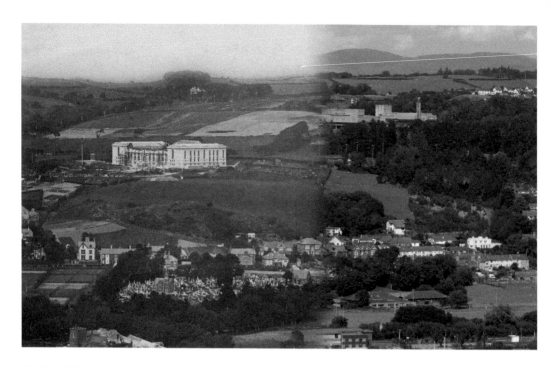

National Library of Wales

In the earlier view of the National Library, *c.* 1935, the central block is being constructed, whilst in the recent view scaffolding covers the Library in an attempt to reverse the damage done by eighty years of storms, wind and rain. It may surprise some to learn that the sun doesn't always shine in Aberystwyth. Building on the university campus is yet to start in the older view. Also of note are the ribbon development between the town and Llanbadarn, Plascrug nurseries and two mortuary chapels in the cemetery.

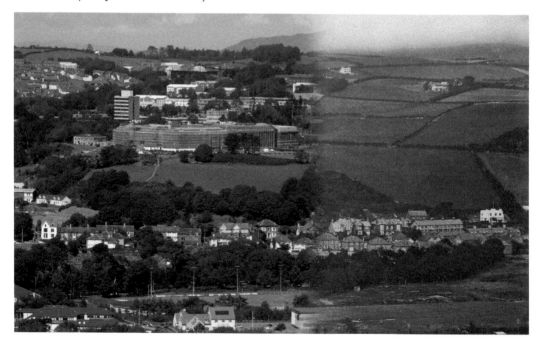

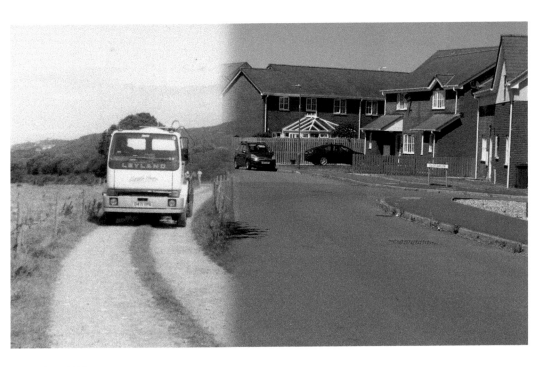

Parc Y Llyn

Parc Y Llyn was the name of a dairy farm that stood in the Rheidol Valley between Llanbadarn and Penparcau. In 1990 Chelverton Developments embarked on a project to build a 4,400 square metre supermarket for Safeway and other non-food retail units on the land. Four years later planning permission was granted for this housing covering an area of 25 acres. The original farm was demolished and the Ystwyth Medical Practice built on the site.

Road to Nowhere

Adjacent to the housing at Parc y Llyn is the eastern approach road, known for many years as the road to nowhere but officially named Boulevard de Saint Brieuc in honour of our twin town in Brittany. The road was completed in 1995 opening up further swathes of the flood plain for development.

Parc Y Llyn Path

Developments here include The Starling Cloud, described by Marston's as 'a family-friendly, new-build pub and lodge serving restaurant-style food'. The name comes from the spectacular murmuration of starlings to be seen over the pier during the autumn and winter evenings, featured in episode 7 of *Autumnwatch* in 2010. Close by are local and Welsh Government offices.

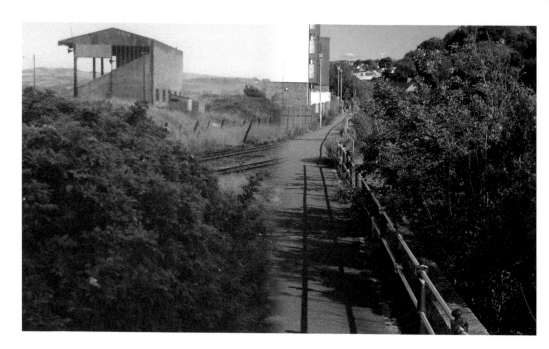

Riverside Walk

The original inelegant corrugated iron engine sheds for the Vale of Rheidol stood in this part of town. Since their removal the area has become a pleasant riverside walk. Dominating the recent photo and dwarfing the Rhun Owen Stand is a block of thirty-three one and two-bedroom apartments that overlook Park Avenue football ground on the left and the River Rheidol on the right. Construction of these started in December 2017 and is now complete.

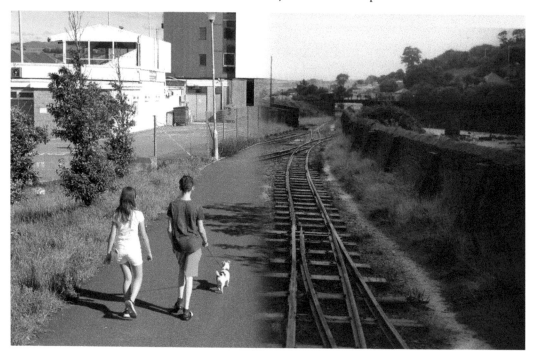

Park Avenue Crossing

The original Vale of Rheidol line crossed Park Avenue opposite the present-day Rheidol Retail Park, causing not inconsiderable inconvenience for some and an entertaining spectacle for others. The closure of the Aberystwyth to Carmarthen line and other factors created more space at the main station so by 1968 the crossing here had been dispensed with as all engines and rolling stock could be accommodated in the old standard gauge engine shed, still used for the purpose today.

Glyndwr Road and Drill Hall

Glyndwr Road comprised a row of twelve neat terraced houses and at the far end Aberystwyth's Drill Hall. In 2013 plans were submitted for development to include a Tesco supermarket on the site of the adjacent Mill Street car park. The plan also involved the demolition of all twelve houses, the Drill Hall and the purpose-built Day Centre on Park Avenue.

Glyndwr Road II

Despite objections to the demolition of houses, Drill Hall and Day Centre the new development went ahead. The site was developed to provide a car park for 550 cars, Tesco Supermarket and a long overdue and eagerly anticipated Marks and Spencer.

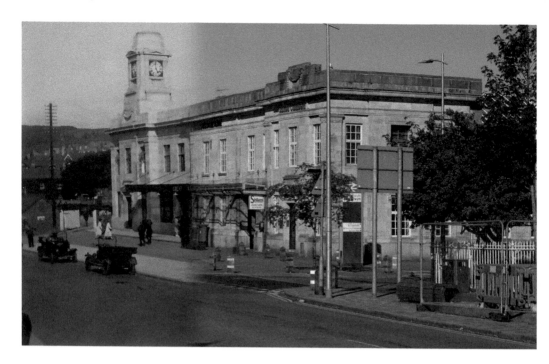

Railway Station

Aberystwyth's two-storey railway station was built in 1924–25 following the Great Western Railway takeover of the Cambrian Railways. By the end of the last century rail traffic had decreased and the station building had become something of a white elephant. The building was sold and converted into a Wetherspoon pub, appropriately called Yr Hen Orsaf (The Old Station). The conversion won a National Railway Heritage Award in 2003. Other parts of the building house offices and until recently an Indian restaurant.

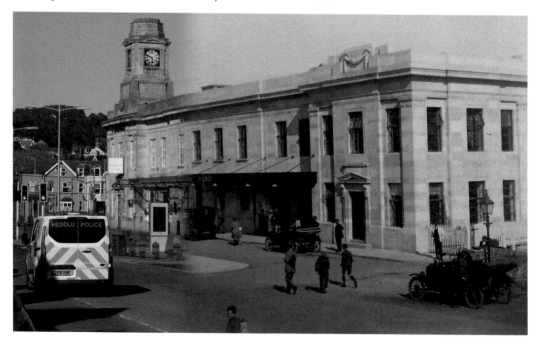

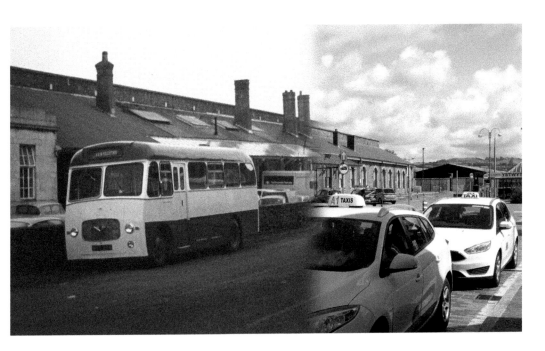

Aberystwyth Railway Station and Taxi Rank

Following the sale of the main railway building, greater use of the modified side entrance was encouraged. In 2016 Network Rail spent £3.1 million revamping the station, parts of which date from 1872. The most radical manifestation of this is the 'fan-like' glazed entrance canopy made of heat-soaked toughened laminated glass and stainless steel. What is now a taxi rank was until the construction of the present-day bus station used by numerous buses including this quaint 1961 red and cream bus belonging to James of Ammanford, photographed *c.* 1973.

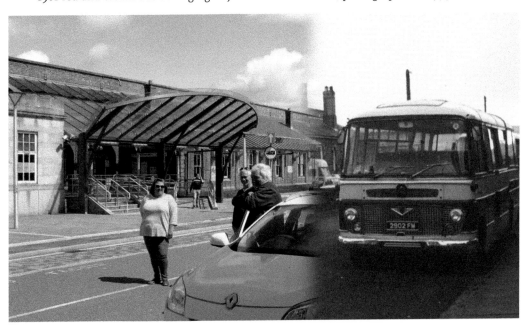

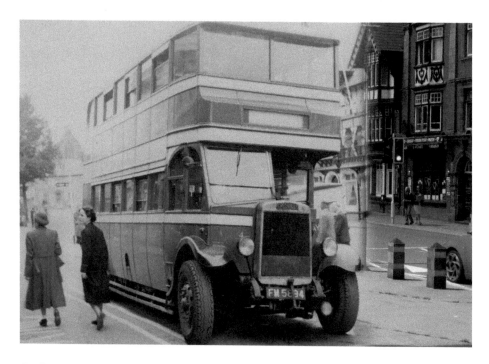

Station Forecourt

There is a substantial paved area in front of Yr Hen Orsaf. Until its recent conversion vehicles including buses could deliver their passengers right to the station's door. Before the present building was erected the original Victorian station frontage occupied the spot. The current building was built behind the Victorian structure, which was then demolished on completion of its successor, leaving a convenient drop-off place for pedestrians to alight.

Kerry Evans

For many of a certain generation Kerry Evans sweet shop and newsagent was a convenient diversion on the walk home from school. It was here that one could purchase those snacks necessary for sustenance on the rest of the journey. It is now Le Figaro, a family-style restaurant serving sustenance of a far more nutritious nature.

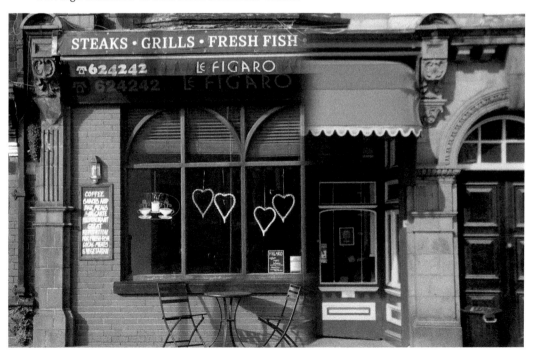

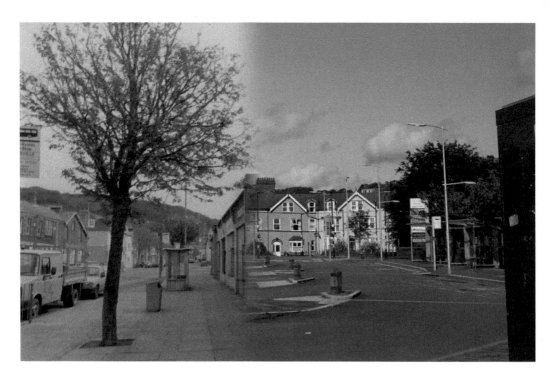

Western Parade

Part of the development of the station area by the Great Western Railway included Western Parade, a row of small shops that until its demolition included a coal merchant, clock repairer, china shop and Christian bookshop. The shops were demolished to make way for a retail outlet and a bus station.

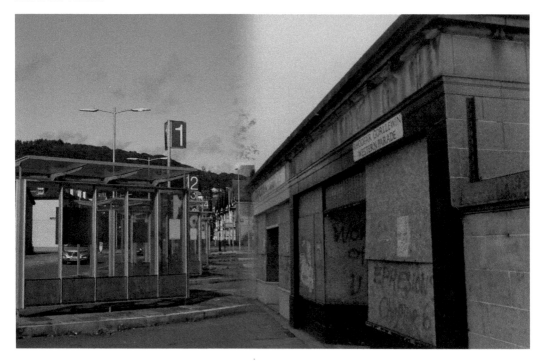

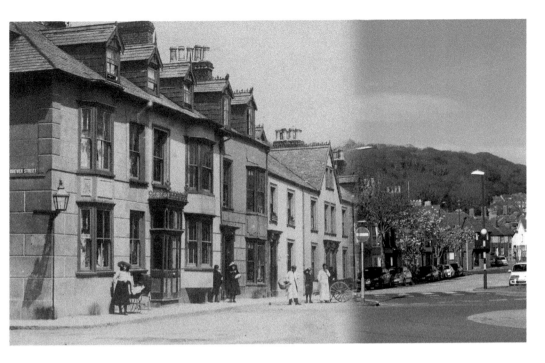

Alexandra Road

Until the visit of Princess Alexandra to the town in June 1896 the street was named Lewis Terrace after Dafydd Lewis, originally from Llangwyryfon. Starting in the 1820s the entrepreneurial Lewis developed a number of streets in this part of town including Cambrian Street, Thespian Street, Lower Terrace Road and these fine houses in Alexandra Road.

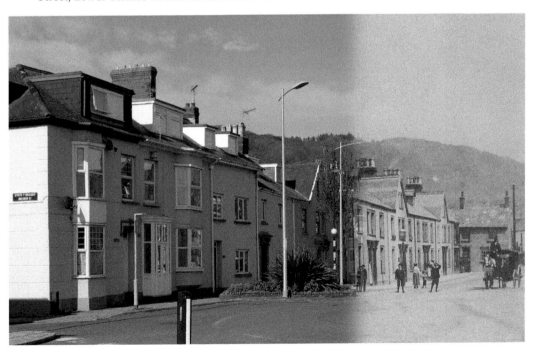

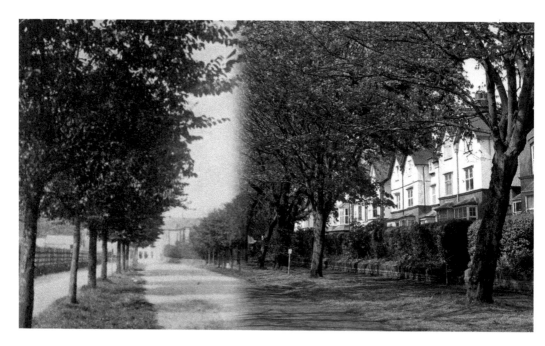

Plascrug Avenue

The mature trees of Plascrug Avenue including Wych Elm and Norway maple provide welcome shade from the summer heat. The avenue is a popular venue for many activities including the local Parkrun every Saturday morning.

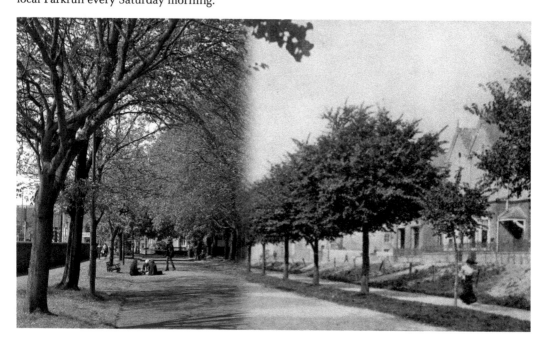

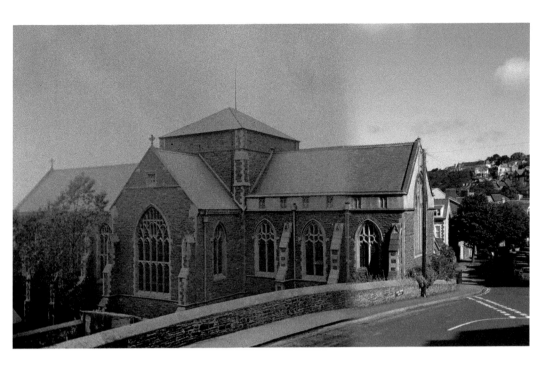

Holy Trinity Church

By 1880 Aberystwyth was a rapidly expanding town. The only church at the time, St Michael's, was now too small (and damp). Fortunately Miss Morice of Carrog, Llanddeiniol, left a considerable legacy to help towards the cost of a new church in the town. This site was found on the Buarth and construction started in 1883. Holy Trinity was consecrated in 1886, though it was not until 1889 that the 530-seat church was deemed complete. The church still thrives today.

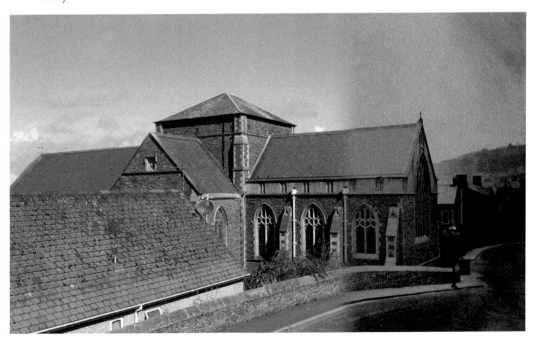

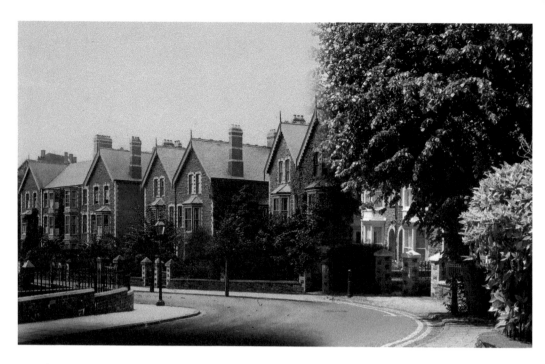

Caradoc Road

This leafy street of elegant Victorian villas was built on land, which, along with nearby Iorwerth Avenue, was once known as The Cricket Fields. An even older name was Cae'r Gog, (tr. the cuckoo's field). Plots for building on Caradoc Road were first offered for sale in June 1888 and building soon followed. Plots in nearby Iorwerth Avenue were then offered for sale in 1899.

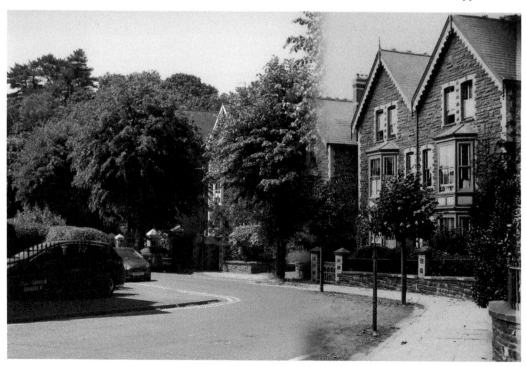

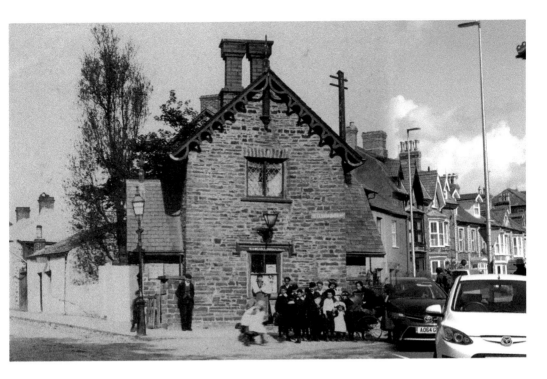

North Tollgate

At the junction of Penglais and Llanbadarn Roads stood a tollgate, demolished many years ago to ease traffic flow. To many people this marked the boundary of North and South Wales. Northgate street leads to this junction and derives its name from the tollgate.

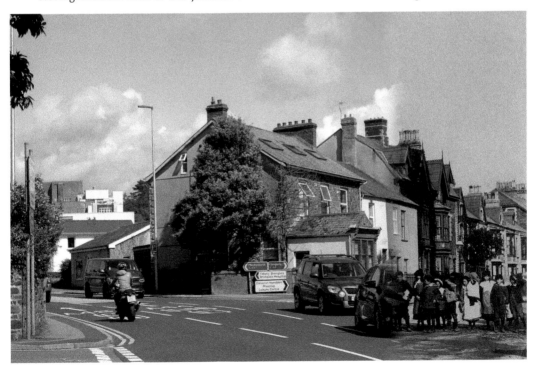

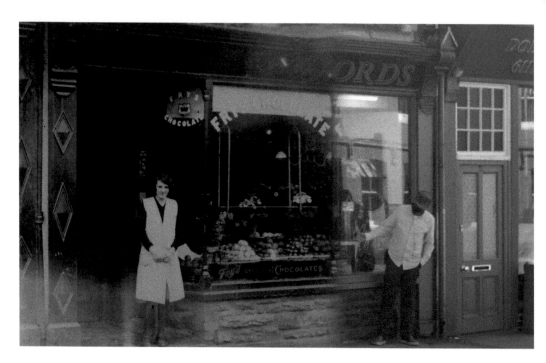

Andy's Records

Lining the southern side of Northgate Street are numerous small shops, today including Andy's Records, 'West Wales Finest independent Music Emporium', in premises that once housed a fruit and vegetable shop, which sensibly also sold Fry's Chocolate – Fry's and Cadbury merged in 1919. Shops on this side of the street facing north so they get little direct sun, an advantage for those selling fresh food.

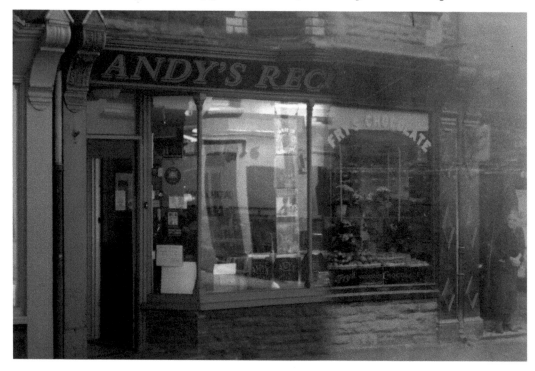

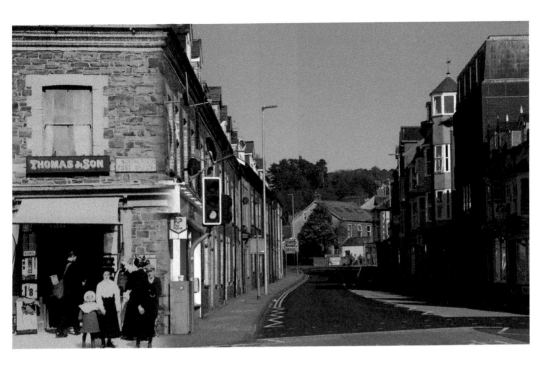

Northgate Street

Named after the tollgate visible in the distance in the older view, Northgate Street consists of houses on the north, south-facing side and shops on the south, north-facing side. The post box outside the Spar convenience store is a reminder that this was once a post office, though the first post office in the street was in a shop at the junction of Northgate and Skinner Street, which opened in 1893 but was referred to as the Old Post Office by 1906.

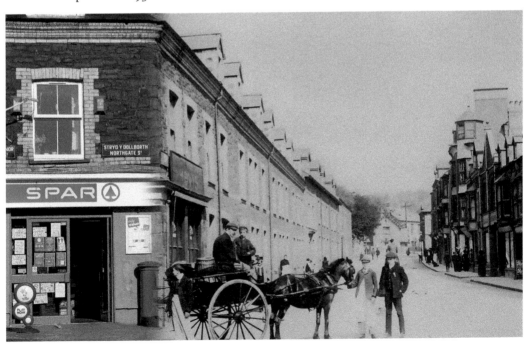

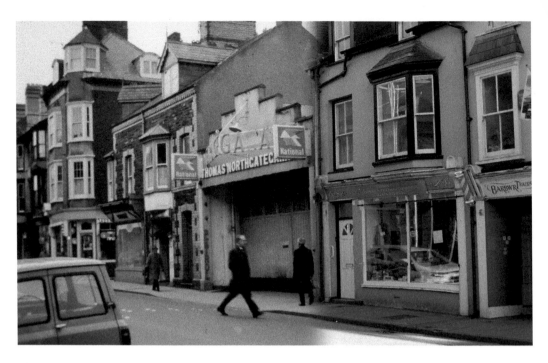

Thomas Garage, Northgate Street

Seen *c.* 1972, Thomas Garage evolved from a foundry that once made mining and agricultural equipment. The site was redeveloped a few years later into a government building that once housed DHSS offices. They have since been converted into student accommodation. Next door down was Knights Newsagents.

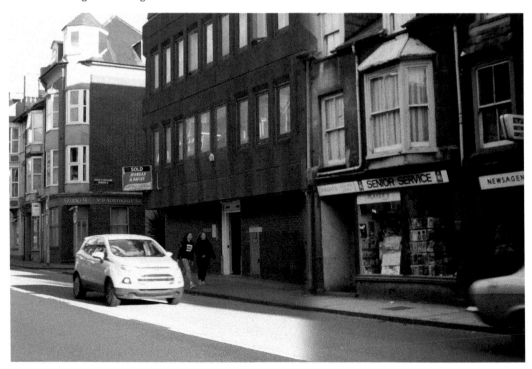

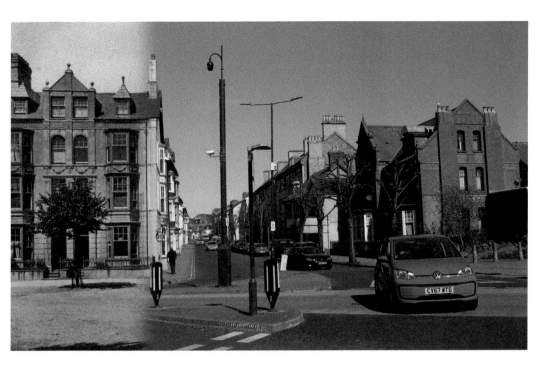

Queens Road

So named because it led to the Queens Hotel, the older Welsh name Morfa Swnd (Sandmarsh) is a reminder of the low-lying and sandy nature of this part of town. Even today this area is not immune from flash flooding. The unstable nature of the ground ultimately led to the demise of Seilo Chapel, partly visible on the extreme right of the older photo.

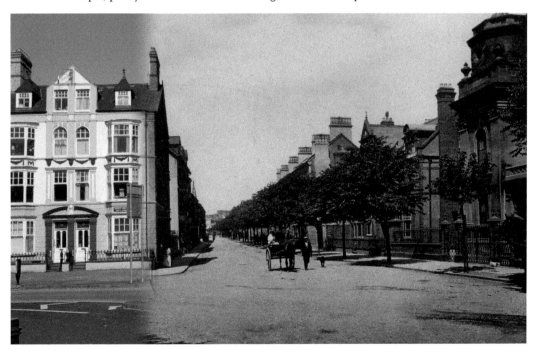

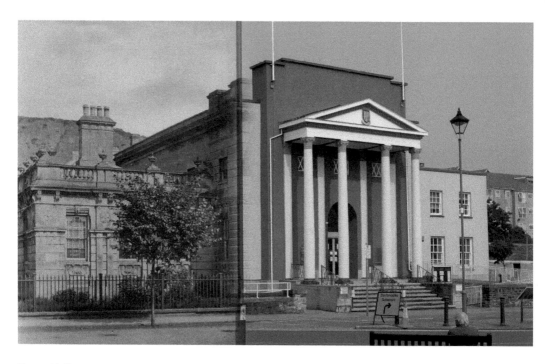

Town Hall

The first town hall on this site was built in 1851 with a grant of £400 from the Treasury to enable the County Court to be held there. In 1957 fire destroyed much of the old building. The present structure was built in a similar shape and officially opened on 2 May 1962. Since the construction of the imposing Canolfan Rheidol local government offices the building now houses the town library, Ceredigion Archives and the displaced Day Centre (see pages 44 and 45).

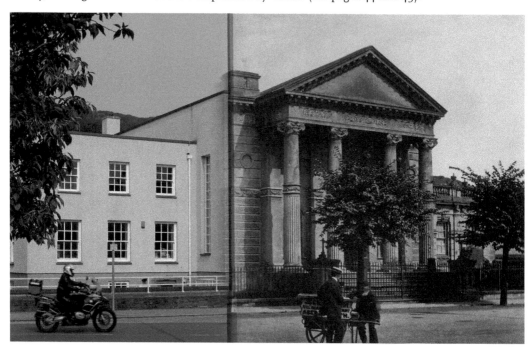

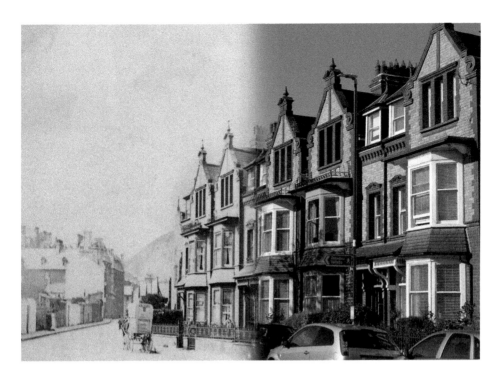

Cambridge Terrace

This part of Queens Road was developed by hotelier W. H. Palmer (1839–1907), owner of both the Queens Hotel and Belle Vue Hotel. Palmer was brought up in the Hoop Hotel, Cambridge, and named the Terrace after the town of his infant nurture.

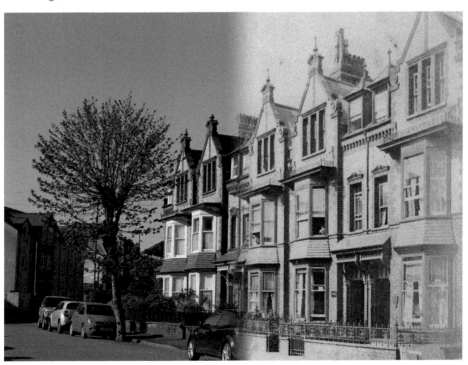

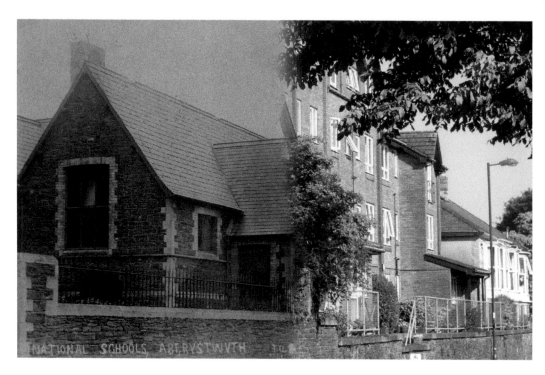

Llys Yr Hen Ysgol

Built on the site of the old North Road School – which ceased to be a school in 1952 – Llys Hen Ysgol provides sheltered accommodation for older residents. The National School that stood there previously was built in 1866 and served as a school until 1955 before becoming a part of the College of Further Education.

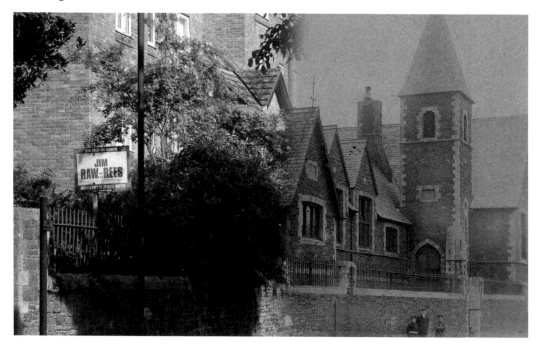

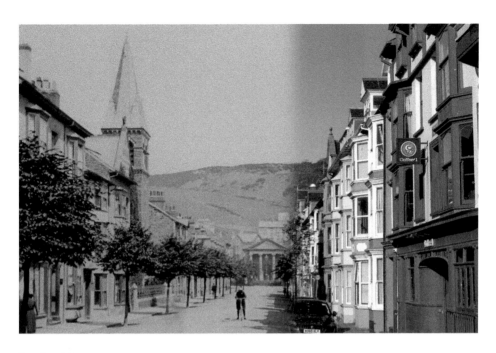

Portland Street

By 1851 this street was characterised by a mix of social classes, and was mainly residential with some business premises and a few inns. The Victorian view is dominated by the tower on the United Reformed Church, now the Church Surgery. Built on the site of two gardens, the church opened in July 1866, catering to an English-speaking congregation.

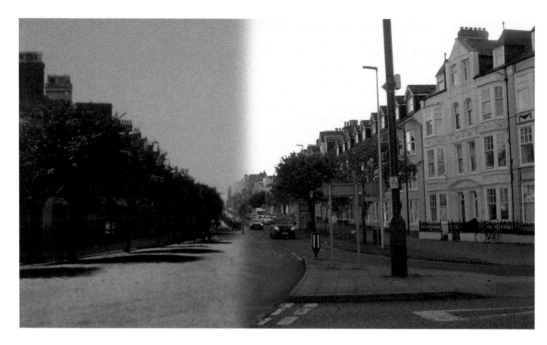

North Parade

This area was used by the local militia as a parade ground during the Napoleonic Wars, hence the name. North Parade is characterised by late Georgian three-storey houses with two windows on each floor fronting the street. In the earlier view the street is lined with elm trees. These fell victim to Dutch Elm disease in the early 1970s.

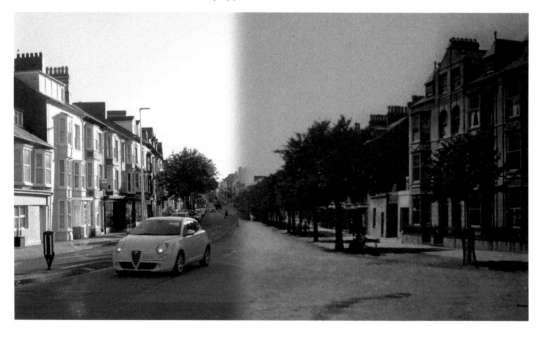

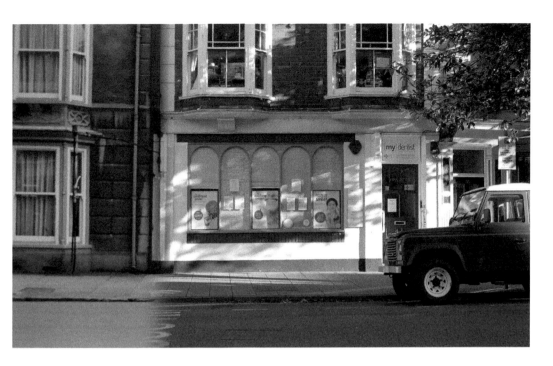

North Parade Garage

Being one of the main thoroughfares into town, this area had no fewer than five garages until the 1970s. Keeping petrol pumps so close to housing now seems unthinkable but was an accepted fact and as far as can be determined was without incident, locally at least. The premises are now a dental surgery.

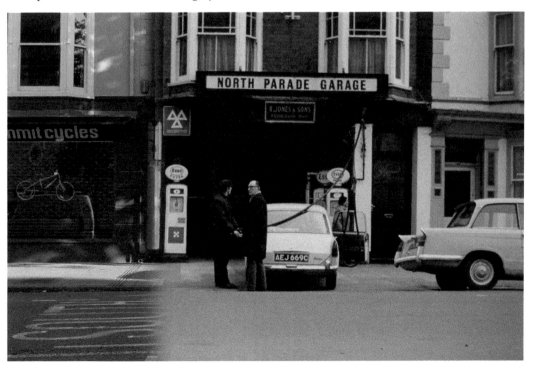

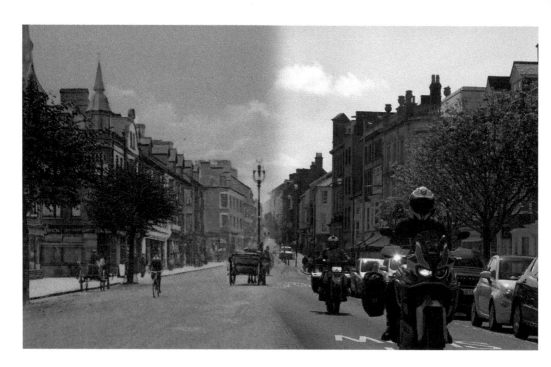

North Parade

Of most obvious note is the sleepy nature of North Parade in the Edwardian era: just one horse-drawn Landau, an Edwardian taxi, is waiting for customers in the middle of what is now a busy thoroughfare through the town. In even earlier times, the ground being low-lying and liable to flooding, women coming to town to sell their produce often had to take a boat from the foot of Penglais to the bottom of Great Darkgate Street.

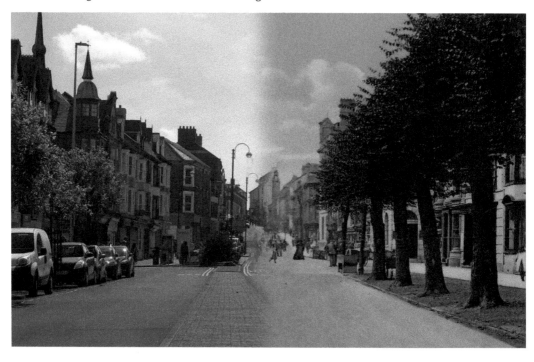

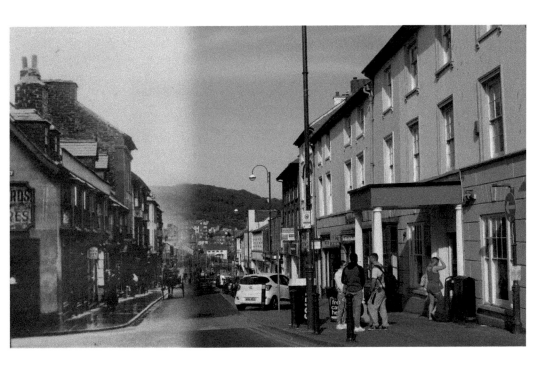

Great Darkgate Street

Great Darkgate Street continues to be the town's main shopping street. Economic conditions have not been kind of late and many shops are empty, including the imposing building on the right. This was the Lion Royal Hotel when the earlier photograph was taken. As such it was one of the town's leading coaching inns and 150 or so years ago often the meeting place of the infamous 'Smokey Face' dining (and drinking) club. It was later purchased by the university and converted to Padarn Hall of Residence.

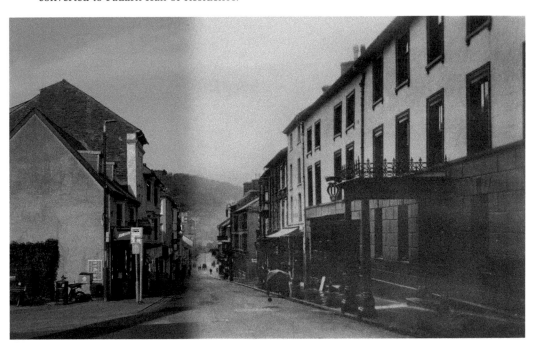

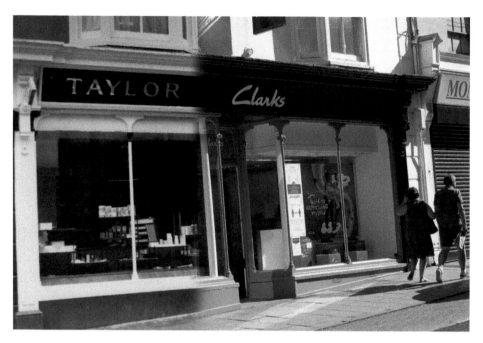

Taylor Lloyd

Taylor Lloyd was a fixture of Great Darkgate Street for decades, kept first by Colonel Bertie Taylor Lloyd MC, a First World War veteran, and subsequently by his son-in-law Gwyn Martin, a keen photographer and Rugby Club stalwart. Gwyn Martin served in the RAF during the Second World War and was shot down over Norway. He recalled his days as a prisoner of war in *Up and Under'*, published in 1989.

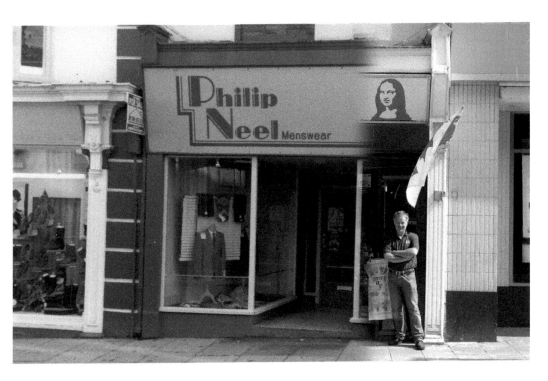

Philip Neel

Philip Neel opened menswear shops in Aberystwyth and Carmarthen during the early 1980s. Now the premises house Mona Liza, a popular gift and souvenir shop selling a wide range of Welsh-themed souvenirs.

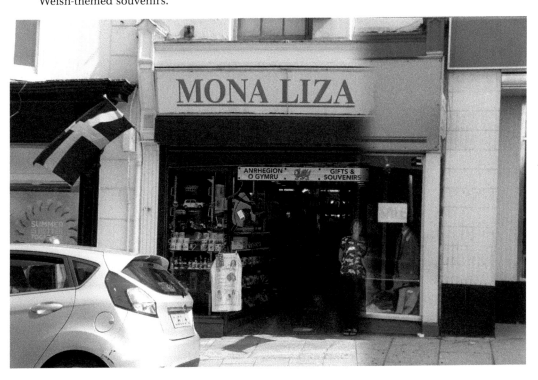

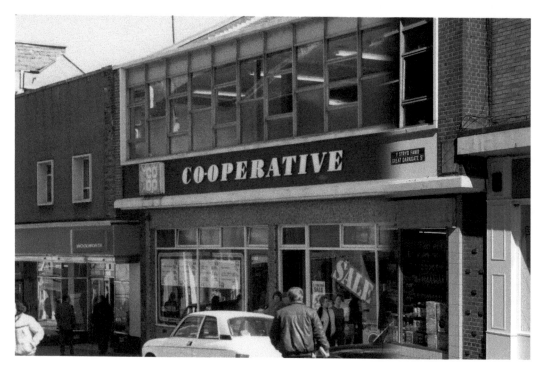

Co-operative

Aberystwyth's Co-op was another shop that seemed to have always been there. Personally I always dreaded being marched to the upstairs as this meant a new school uniform for the forthcoming autumn term and a reminder that the endless summer holidays were about to end.

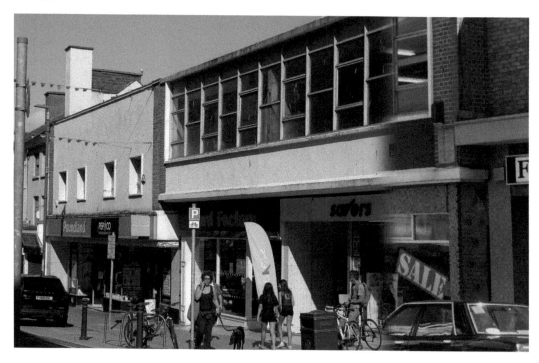

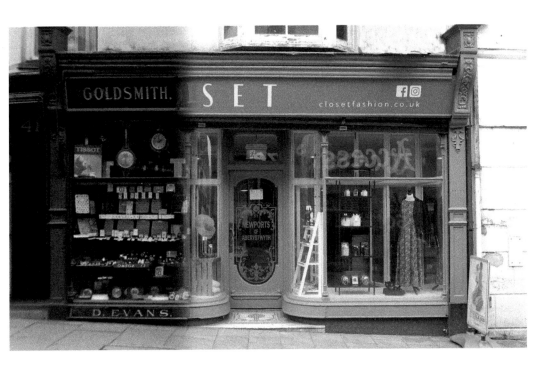

D. Evans, Jeweller

If ever prizes had been given for the most interesting window display then surely David Evans, Watchmaker, Jeweller and Silversmith, would have won hands down year after year. Following closure of the business it was briefly a Thorntons chocolate shop. Unfortunately Thorntons, like many high street chain stores, has deserted Aberystwyth.

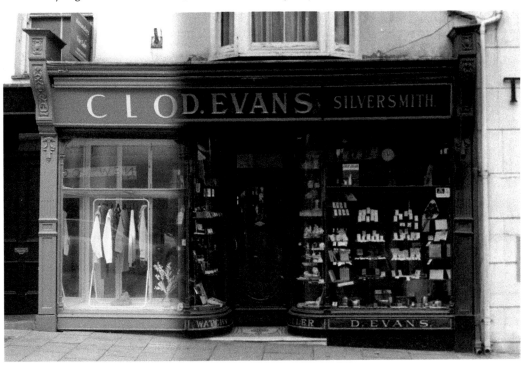

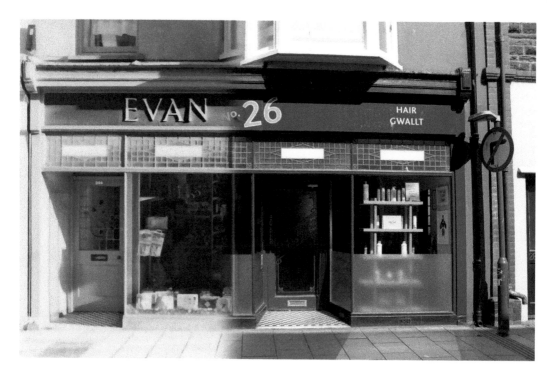

Evan Jones

Evan Jones started selling and repairing radios in his shop in Chalybeate Street. Later televisions became the mainstay of the business, which remained in family hands until his son Ralph retired in 1999. The site was occupied by Mecca coffee shop for many years before becoming a gents' hairdresser.

Nags Head

The Nags Head was a pub as far back as the 1830s. It was purchased by Wolverhampton & Dudley Breweries and for much of the last century was one of a small number of pubs selling Banks's beers in the town. The door by the bay window led to a small, cosy carpeted Lounge Bar whilst the main door led into the more spartan public bar. Even in the 1980s you paid a penny or two more for your pint if you sat in the Lounge Bar. The Nags Head finally closed in 2016 and is now an antique shop.

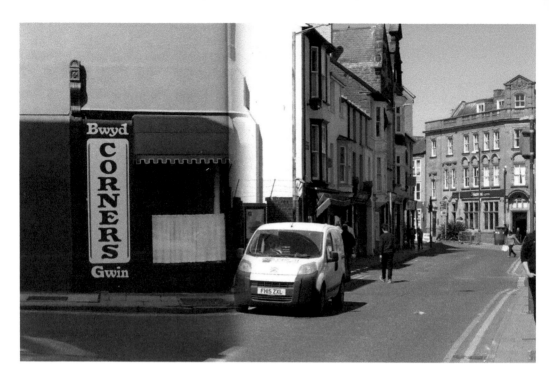

Corners

A popular bistro in premises that had previously been a car accessory shop, Corners was one of a number of excellent bistro restaurants that thrived in the 1980s and 1990s. It is now a florist's shop.

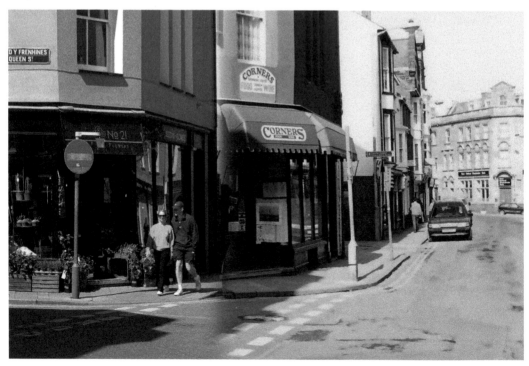

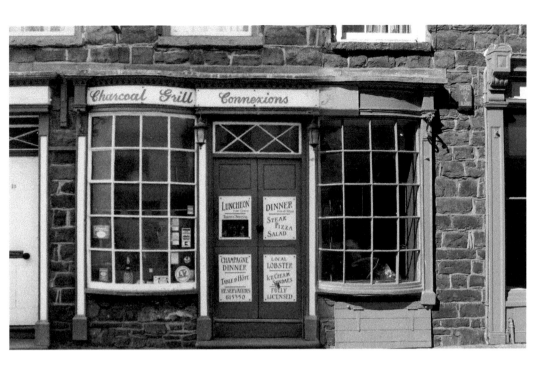

Connexions

Characterised by two late eighteenth-century bow windows, Connexions was another of Aberystwyth's bistro restaurants. As one diner recalled, 'It seemed very sophisticated. They put toasted sunflower seeds on the table for nibbles. Delicious!' Apart from its excellent menu it was also famous for having a macaw, some say a pair, that would be put on a perch in the doorway when the restaurant was closed. Later the premises served briefly as a bottle bar before becoming a ladies' hairstylist.

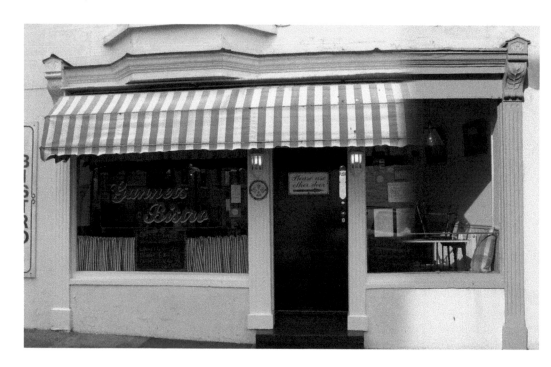

Gannets

Completing the triumvirate of 1980s bistros in Aberystwyth is Gannets, which was also the longest lasting from 1984 to 2018. It was said of Gannets that you never went home hungry and this was certainly the author's experience. The sweet trolley was something to behold! Today it is Dragonfly, an appetising vegetarian and vegan bistro that upholds the town's tradition of varied and fine dining – but is there a sweet trolley?

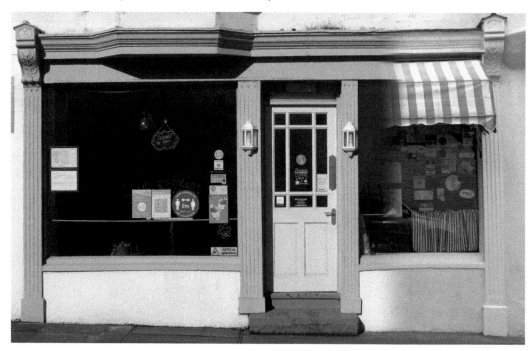

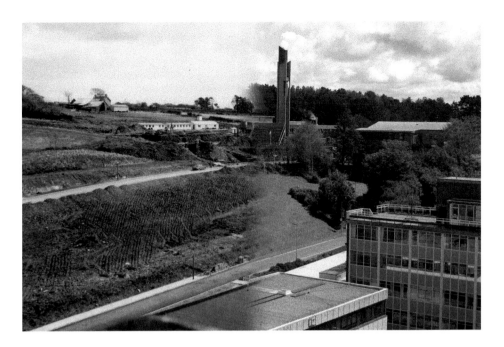

Aberystwyth Arts Centre

Built in a commanding spot with views over Cardigan Bay, Aberystwyth Arts Centre/ Canolfan Y Celfyddydau is a vital part of the life of the town. Facilities include the Great Hall, Theatr y Werin, cinema, dance studios, a photography darkroom, café, bar, studios, shop and four gallery spaces. It is Wales' largest arts centre with a wide-ranging artistic programme including drama, dance, music, visual arts and film. The Great Hall, seating 900 people, was the first part to be built, opening in 1970. Theatr y Werin followed two years later in 1972. Since then more additions have been made. (Older photograph courtesy Peter Henley)

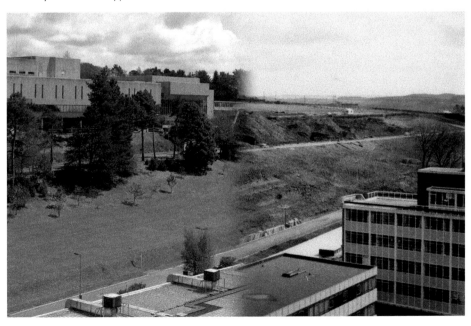

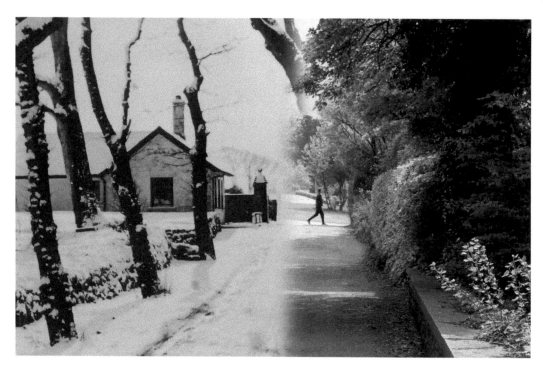

Penglais Lodge

Opposite the main entrance to the university campus is a narrow turning. This leads to Plas Penglais, once the seat of the Richardes family but since 1946 the home of the Principal of the university. The turning is marked by this quaint lodge, recently refurbished.

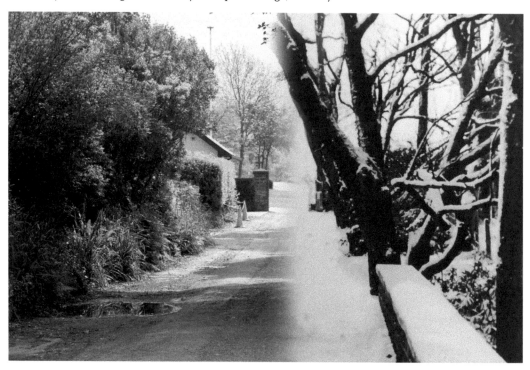

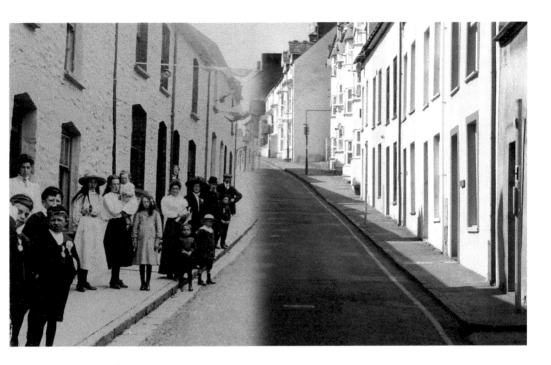

Grays Inn Road, Coronation, 1911

The coronation of King George V and Queen Mary on 22 June 1911 energised the town, excited by the knowledge that within a month the royal couple would visit Aberystwyth. Church and chapel services were held in the morning. The highlight of the day was the Coronation Parade in which the Royal Naval Reserve, Firemen, Boy Scouts, Rechabites and numerous other organisations paraded through the town. These boys in Grays Inn Road are wearing their commemorative medals. Without television or radio townspeople had to wait to see the Coronation on cinema newsreels.

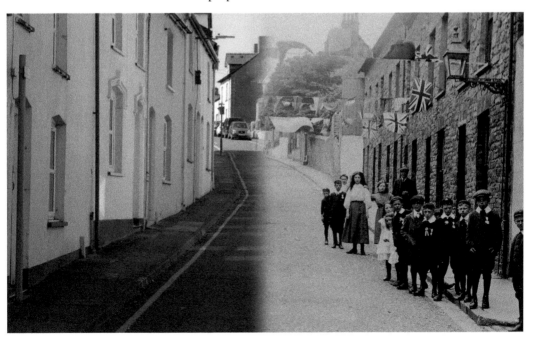

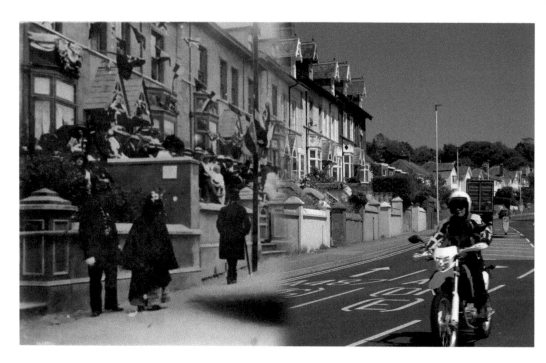

Royal Visit, Penglais Road

The newly crowned King George V and Queen Mary visited Aberystwyth on 15 July 1911. Enterprising house-holders at the bottom of Penglais Hill charged sightseers a fee to sit in their front gardens to watch the royal entourage pass up the hill in an open carriage to lay the foundation stone of the nascent National Library of Wales.

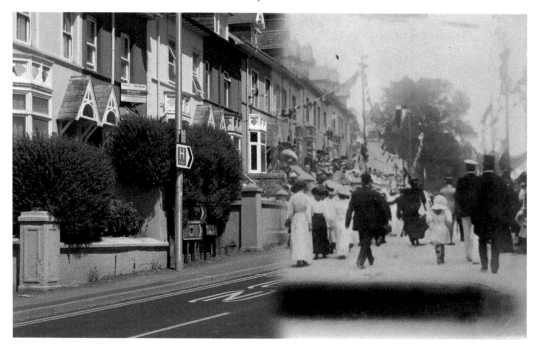

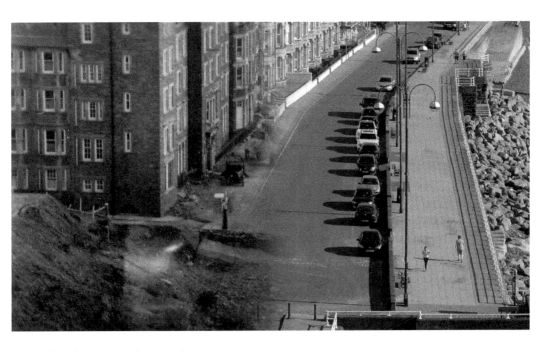

Victoria Terrace after the Storm, January 1938

Friday 14 January 1938 started much like any other January day, but by late evening a ferocious storm was whipping up the sea. Witnesses agreed that the storm reached a crescendo at about five o'clock the next morning when 90 mph winds raged and wave after wave flooded the houses, breaking down doors and smashing windows. Shortly afterwards the promenade wall collapsed. The waves now threatened at one point to wash away the foundations of the houses themselves. The apron of boulders in front of the sea wall now hopefully protects against repetition in the future.

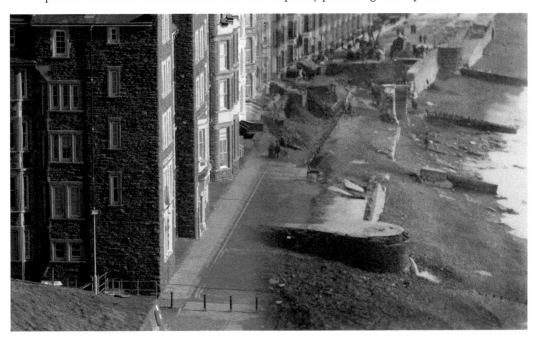

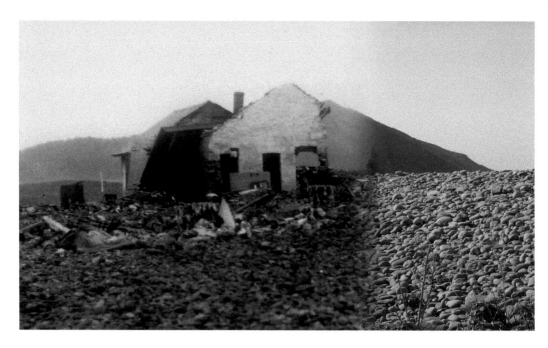

The Cottage, Tanybwlch

Although the damage to Victoria Terrace was extensive, greater devastation befell this cottage, once the Infectious Disease Hospital, on Tanybwlch beach. This was the home of Mrs Linnett and her two daughters. As the storm raged they were about to abandon their cottage when two waves in succession reduced the cottage to ruins, trapping the Linnetts and their cat. Quick thinking by the driver of a passing train alerted the authorities and all, including the cat, were rescued. Now nothing remains to remind these Sunday morning walkers that a cottage once stood on the spot.

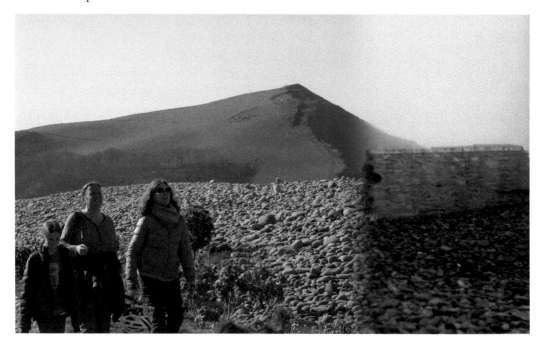

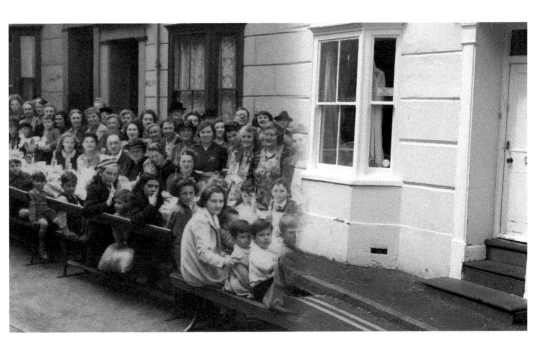

VE Day, Powell Street

Tuesday 8 May 1945 marked the surrender of the Axis forces and the end of the Second World War in Europe. Throughout Britain street parties were held and whatever rations had been saved brought out and contributed to the festivities. The newer photograph taken from the railings in front of the now demolished Tabernacle was taken seventy-five years to the day with no indication of the historical event being evident.

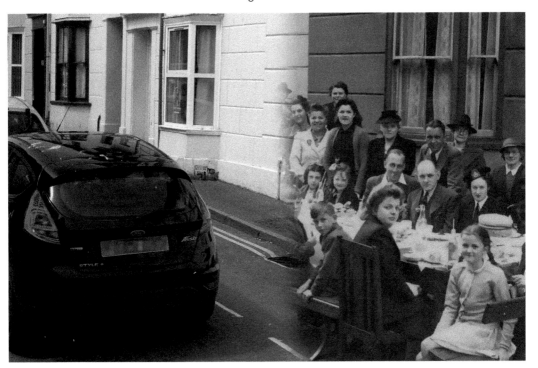

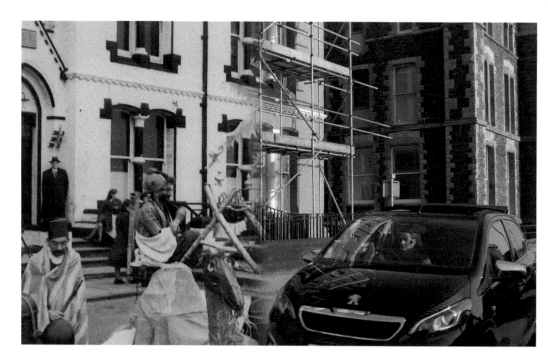

Rag Procession, Victoria Terrace

As seen here in 1950 Victoria Terrace was the assembly point for the students' annual rag parade, a fundraising tradition dating back probably to the 1920s. Seen here is the Plas Hendre float passing Victoria House, once a Ladies Collegiate School. By the mid-1970s the carnival procession had become a raucous affair with flour, eggs and seaweed being flung about the streets. After a particularly messy event in 1976 the carnival procession, by now contributing only £50 to the coffers and rapidly losing the goodwill of the townspeople, was held for the last time.

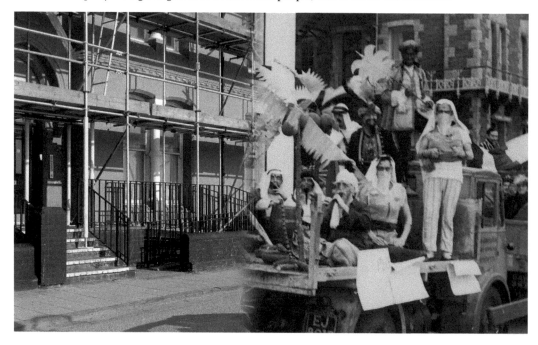

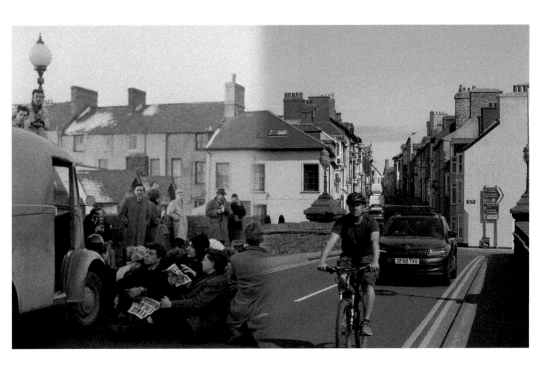

Cymdeithas Yr Iaith Protest, Trefechan Bridge

Student antics of a different and more high-minded nature took place on Trefechan Bridge on 2 February 1963 when students from Aberystwyth and Bangor staged a sit-down protest to raise awareness about the lack of official status for the Welsh language. This was to be the first of many protests by Cymdeithas Yr Iaith Gymraeg (The Welsh Language Society) over the coming decades. Reminiscing fifty years later, one of the participants noted 'The locals didn't like it very much'. A plaque, visible on the left in the new photo, now commemorates the event.

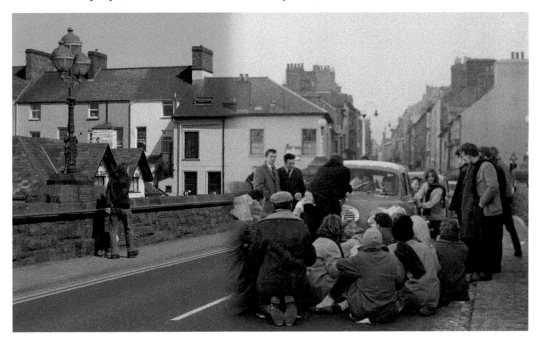

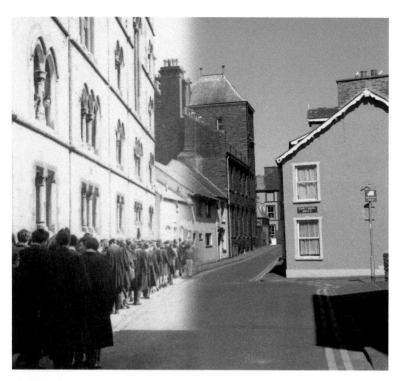

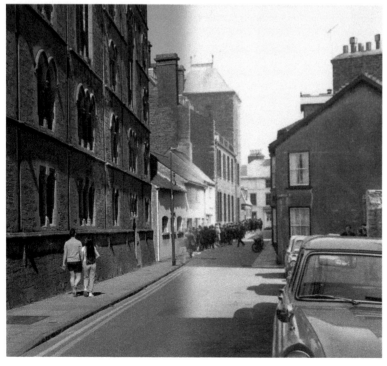

Graduands, King Street, *c.* 1965 Since its opening graduation ceremonies were held in the Kings Hall. The site of students in gowns and mortar boards marching from the Old College along King Street and along the promenade to the Kings Hall and later posing for photographs outside added an element of theatricality to the town, now lost since graduation ceremonies take place in the Great Hall on the Penglais campus.

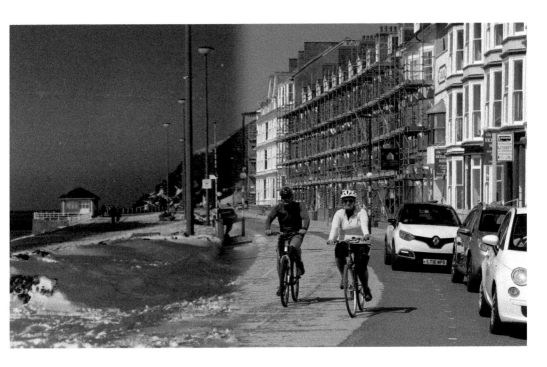

Snow on the Promenade

January 1982 saw Aberystwyth gripped by another bout of inclement weather, this time a blizzard. Dry powdery snow backed by an easterly wind started falling on 7 January and continued for thirty-six hours and drifted across roads, even carpeting the promenade. Roads running north to south were noted as having been particularly affected as the snow accumulated between hedges and banks.

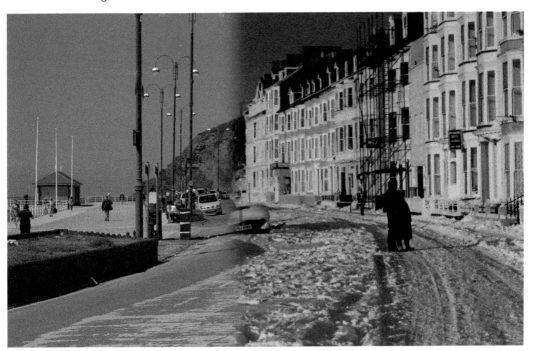

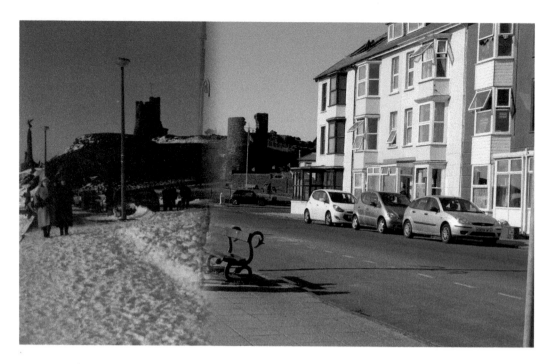

Snow, South Marine Terrace

Aberystwyth was cut off as all roads and the railway line were blocked by snowdrifts, and snowmen appeared in their hundreds. Power lines were damaged by frozen branches falling from trees. Royal Mail sent a post from Aberystwyth by sea to Aberaeron and helicopters were frequently seen taking emergency supplies to outlying areas. South Marine Terrace was particularly affected and the road was blocked.

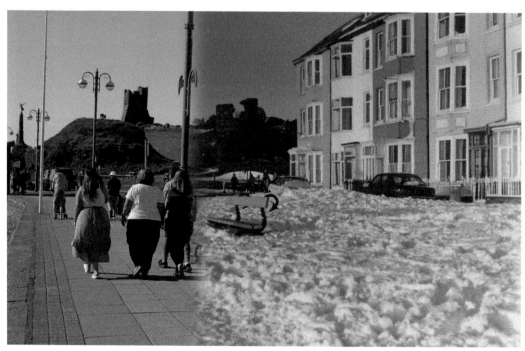

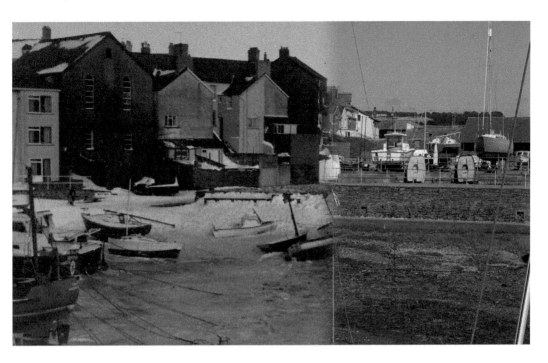

Snow, Aberystwyth Harbour

For the first time in living memory the harbour froze over with Y Geulan, the area once used to build ships, being particularly snowbound. In the older photo a variety of small boats including *Glas Y Dorlan*, *Ton Wen*, *Jaqueta* and *Suzie Wong* are firmly in the grip of the ice and snow.

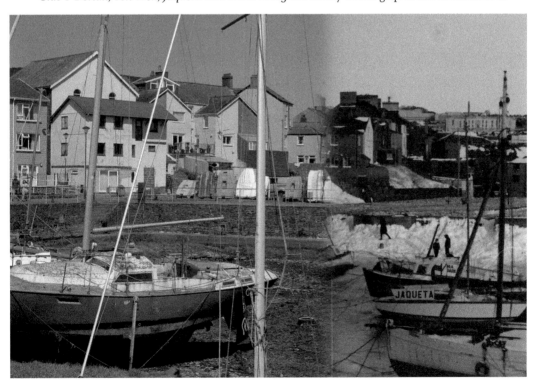

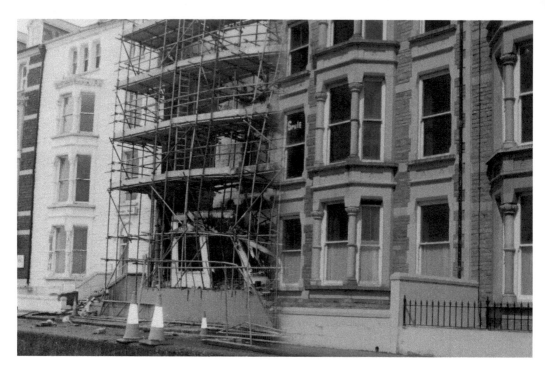

Seabank Hotel Fire I

The Seabank Hotel was established in 1967 and had been a popular and well-run establishment with a comfortable lounge bar. By 1998 it had changed hands, was empty, encased in scaffolding and awaiting renovation. Almost simultaneously at 3.40 a.m. on 3 November 1998 five 999 calls were made reporting that the Seabank Hotel was on fire.

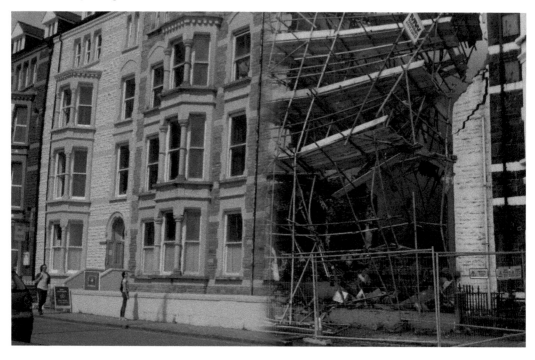

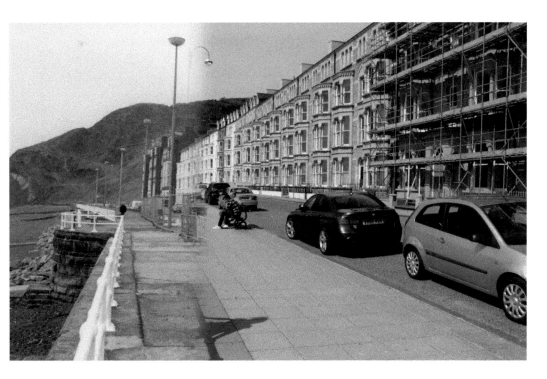

Seabank Hotel Fire II

The fire had a strong hold on the empty hotel and soon spread through the roof space to the adjoining properties on both sides. Fire engines from as far away as Machynlleth and Llanidloes had to be deployed. One reason given for the ferocity of the fire was the presence of scaffolding as the poles facing the front of the hotel sucked air into the building.

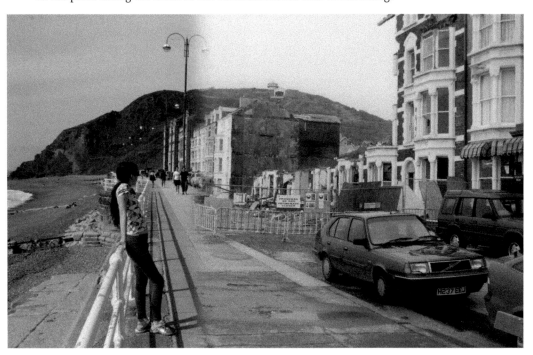

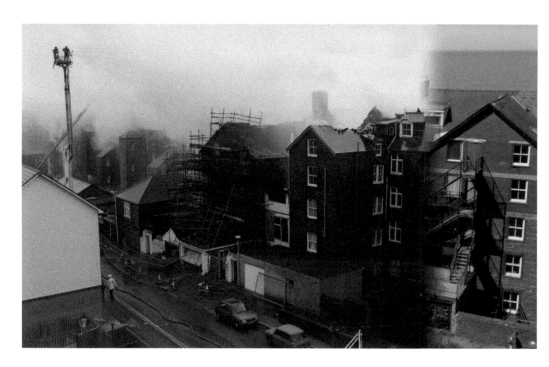

Seabank Hotel Fire III

There were no casualties though as a precaution even the newly built Parc Craiglais flats behind the Seabank had to be evacuated. All the affected sea front buildings had to be demolished. To look at Victoria Terrace now it is difficult to believe such a tragedy took place. The Seabank Hotel was incorporated into a much-enlarged Plynlymon Hall of Residence, whilst the Clarendon (on the far side) was also purchased by Aberystwyth University. When rebuilt the builders proclaimed Plynlymon Hall to be the tallest timber-framed building in Wales.

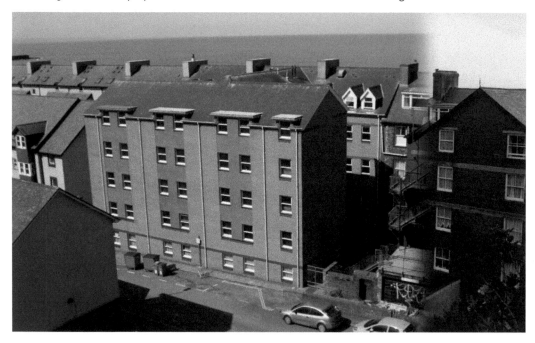

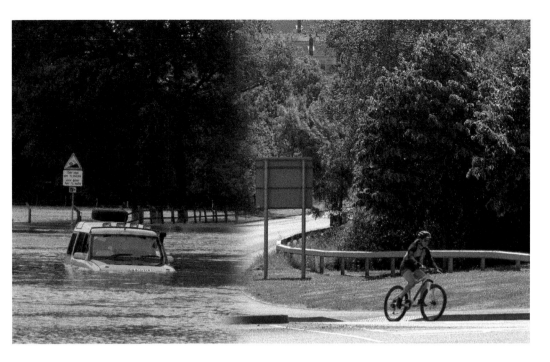

Parc y Llyn Roundabout, 9 July 2012
Up to 10 inches of rain had fallen over the Cambrian Mountains in the preceding two days. Gradually this water worked its way into the River Rheidol, reaching a peak at 1 p.m. as high tide prevented the water escaping into the sea creating a body of water that engulfed Blaendolau playing fields (to a depth of 5 feet), parts of the Parcyllyn Retail Park and especially the Aberystwyth Holiday Village. At one point even the town centre was thought to be under threat.

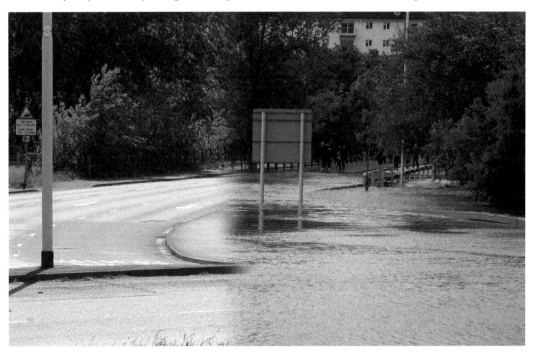

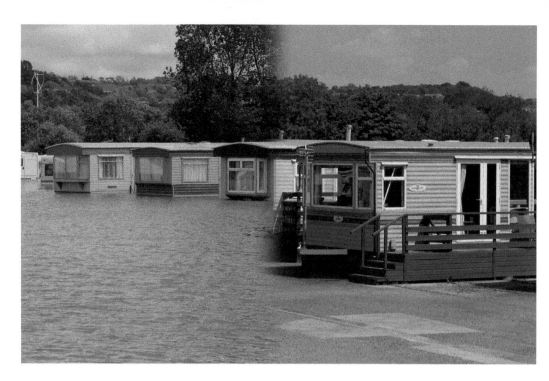

Aberystwyth Holiday Village, 9 July 2012

In the immediate Aberystwyth area the greatest devastation took place in the lower lying parts of Aberystwyth Holiday Village with caravans, motor homes and cars being damaged, many beyond repair. At one point the RNLI Flood Rescue Team was deployed to assist people escaping the floods. In addition the RNLI launched their two boats to act as 'goalkeepers' should anyone fall into the floodwaters and be washed downstream. Thankfully nobody was.

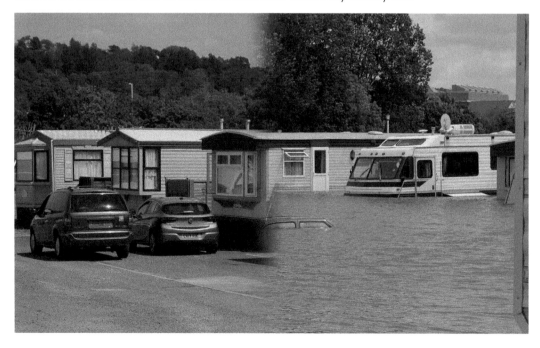

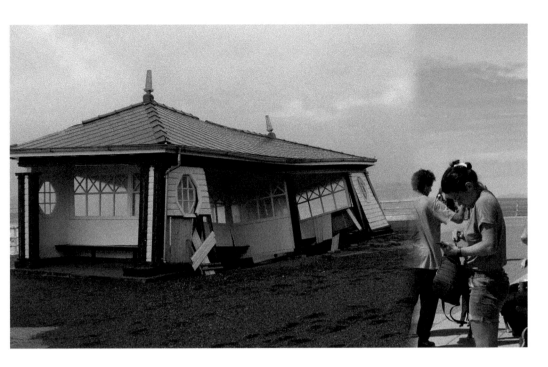

Bath Rock Shelter

The remnants of Cyclone Anne were responsible for much destruction on the prom in January 2014. Much of the damage centred around the portion between the Marine Hotel and the Bath Rock Shelter, the same area ravished by a storm in 1927. The iconic Bath Rock shelter was severely damaged when the retaining wall was breached and the structure fell into the void beneath. It was rebuilt shortly after using as much of the original timber as possible.

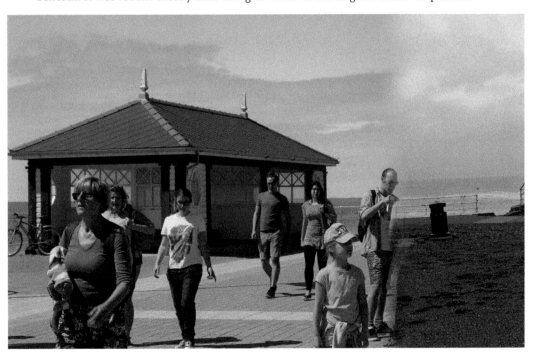

Acknowledgements

Thank you to Lorena, Eluned and Ioan for their co-operation and patience. Thank you to Peter Henley for permission to use his photo of the university campus on page 77, and also to the National Library of Wales for permission to use the older illustrations on pages 32, 37 and 85.